The Fine Print

The Fine Print

Fred Picker

AMPHOTO American Photographic Book Publishing Co., Inc. Garden City, New York

To Lil

Third Printing, 1978

Copyright © 1975 by Fred Picker

Published in Garden City, New York, by American Photographic
Book Publishing Co., Inc. All rights reserved. No part of this
book may be reproduced in any manner whatsoever without the
written consent of the publisher.

Library of Congress Catalogue Card Number 74-83645

ISBN 0-8174-0584-4

Manufactured in the United States of America

Speaking of Photographs

INTRODUCTION

A child strikes a piano key and is surprised and delighted by the result, but a musician can "hear" a passage just by seeing the notes on paper. Beginning photographers rush their film to the processor and wait impatiently until they can see "how they came out." The accomplished photographer can see the final print in his mind's eye in every nuance of tone, detail, and composition before he makes the exposure. This ability to envision a three-dimensional colored subject as it will be represented in a two-dimensional black-and-white print is called "previsualization."

Tone control, the basic fundamental of previsualization, can be learned by anyone willing to spend a few hours making several simple tests with his camera, meter, and enlarger. First, a film speed test is made to determine the proper ASA speed rating for an individual meter and a specific film. This is necessary because there are frequent variations in the materials used; two-stop differences in meters of identical parentage are not unusual, shutter speeds and apertures often do not correspond to the lens markings, and so on. Because of these inconsistencies and a dozen other factors, no meaningful rating recommendation can be made, and manufacturer's ASA ratings can only be regarded as very rough guides. Exact procedures for making a test to identify the proper ASA setting for a particular meter, film, shutter, developer, and the like can be found in my *Zone VI Workshop* (Amphoto, 1974).

A Zone I negative density of .10 above "film base plus fog" indicates that the proper ASA setting has been found. It is not at all uncommon to locate a personal exposure index one-half to twice the recommended setting.

The film speed test locates Zone I (one step above total black in the print). The development time test then locates Zone VIII (one step below pure white in the print). Zone I is the minimum printable density. Zone VIII establishes the maximum printable negative density for a particular enlarger, paper, and print developer. After completion of the film speed test and the development time test, the photographer is able to use his exposure meter to "place" his values before exposure. He can now predetermine the tones of gray that he desires in the finished print. He can apply the Zone System to his work.

The Zone System is based on sensitometric principles that Ansel Adams codified for quick and accurate field use. Adams' description of realistic tonal representations follows.

Low Values

Zone 0.	Complete lack of density in the negative image, other than film-base density plus fog. Total black in print.
Zone I.	Effective threshold. First step above complete black in print. Slight tonality, but no texture.
Zone II.	First suggestion of texture. Deep tonalities, representing the darkest part of the image in which some detail is required.
Zone III.	Average dark materials. Low values showing adequate texture.

Middle Values

Zone IV.	Average dark foliage. Dark stone. Landscape shadow. Recommended shadow value for portraits in sunlight.
Zone V.	Clear north sky (panchromatic rendering). Dark skin. Gray stone. Average weathered wood. *Middle gray* (18% reflectance).

Zone VI. Average Caucasian skin value in sunlight or artificial light, and in diffuse skylight or very soft light. Light stone. Clear north sky (ortho-chromatic rendering). Shadows on snow in sun-lit snowscapes.

High Values
Zone VII. Very light skin. Light-gray objects. Average snow with acute side lighting.
Zone VIII. Whites with textures and delicate values (not blank whites). Snow in full shade. Highlights on Caucasian skin.
Zone IX. Glaring white surfaces. Snow in flat sunlight.

White without texture.
(The only subjects higher than Zone IX would be light sources, either actual or reflected; but they would obviously be rendered in the print as maximum white value of the paper surface.)

To "place" a gray barn on Zone V, take a meter reading and set shutter and aperture as indicated (unmanipulated meter readings produce Zone V). To "place" fleshtones on Zone VI, take a meter reading, then open up one stop, and so on.

After completion of the two tests, my workshop students make exposures placing the value of a card on each Zone (0 through IX). These negatives are then printed in accordance

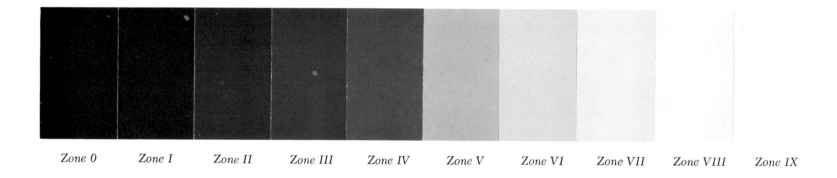

Zone 0 Zone I Zone II Zone III Zone IV Zone V Zone VI Zone VII Zone VIII Zone IX

with standard printing time (minimum enlarging exposure that will produce maximum black through the unexposed film edge). The resulting prints can be seen below.

Each student has made a group of control prints from negatives exposed to record specific tones of gray. From the results, the student knows that any subject placed on any Zone in his future work will match in tonal value the control print made at that placement. Once normal development time is established, the photographer can apply additional creative controls through variable negative development.

NORMAL NEGATIVE DEVELOPMENT TIME

Normal development time is found by exposing a number of negatives of, for instance, a white card in sun whose value is placed on Zone VIII (three stops more than the meter reading). These negatives are then developed for varying times and subsequently printed for the theoretically correct printing time. (The correct printing time is the minimum enlarging exposure that will show the unexposed film edge [Zone 0] as

maximum black.) The properly developed Zone VIII negative will print very slightly darker than the white paper base when subjected to that printing exposure.

Remember, however, that normal development time cannot be located until after the proper film-speed setting for the meter is known; and "normal" for one enlarger is often 25% greater or less than normal for an enlarger of a different brand and as much as 100% different (usually shorter) than the manufacturer's literature indicates.

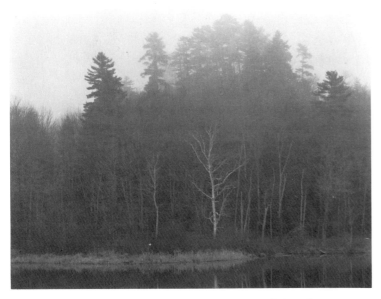

Normal Development

PLUS DEVELOPMENT

It is possible to develop a lower placement to a higher density. The proper additional development time varies with film and developer but usually falls between 35% and 50% longer than normal development. It is found by exposing to Zone VII and testing as above until a Zone VIII density is achieved. In the example shown, plus development can be employed if the desired placement of the gray trees on Zone V caused the white birch to fall on VII when it was visualized as a Zone VIII print value (top print). Normal +1 development (i.e., plus one Zone) increased the Zone VII exposure of the birch to a Zone VIII density (bottom print). The lower values (the gray trees) remain relatively unaffected by the increased development time. Normal +2 development, which raises a Zone VI placement to a Zone VIII density is also possible. Plus developments to expand the film range will separate tones and maximize textural rendition. There is also an increase in grain, so plus developments in excess of +1 should be avoided when film smaller than 4″ x 5″ is used. A 30% overdevelopment is useable for 35mm or 2¼″ x 2¼″ film if the enlargement is to be moderate.

The examples of normal and +1 development were contact printed together on No. 2 paper.

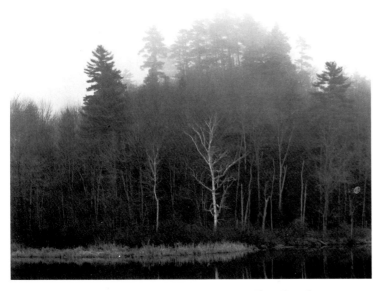

Plus Development

Minus Development

It is also possible to develop a higher zone placement to a lower density. A normal −1 development will reduce a Zone IX placement to a Zone VIII density and a Zone VIII placement to a Zone VII. Although shortened development has the greatest effect on values placed on Zone VI or higher, all values are somewhat affected. Notice in the accompanying example that the floor in the hallway is of lower value in the minus-developed negative in spite of the longer exposure. Longer exposure is always indicated when minus development is used, in order to support the shadow areas. Minus development reduces contrast and minimizes texture. It can be a useful device in portraiture of women in bright sun. Because of the shortened negative development, grain is reduced, so small film is not adversely affected.

The 35mm and roll-film user can enjoy the benefits of variable development if he exposes an entire roll under identical conditions. This is simple with cameras such as the Hasselblad, where three camera backs can be carried and labeled "Normal," "N+1," and "N−1." With 35mm film, a roll can be labeled for special development and inserted in the camera for those situations that would benefit from special development. The number of the last frame exposed is written on the cassette to avoid double exposure.

Why not use either a lower or higher contrast paper to increase or decrease negative contrast? This can, of course, be done, and in many instances even negatives that have received special development are printed on papers other than

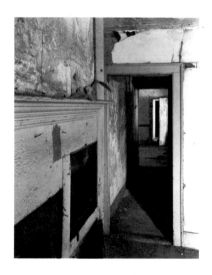

Long Exposure, Minus Development
Sixty-second exposure at *f*/45 with five-minute development. The fireplace interior was placed on Zone IV, the wall to the right of the doorway fell on Zone X. Less than normal development reduced the highest value about two Zones. The lower values are also reduced by short development—notice, for example, the fireplace and the floor shadow.

Normal Exposure, Normal Development
Twenty-second exposure at *f*/45 with normal seven-minute development. The high values, which fell on Zone IX in this case, are textureless. The low values also have greater density than in the other print, in spite of the shorter exposure. (Actually about one-half as much exposure. Reciprocity affects long exposure times, so additional time was given the first negative to compensate. Reciprocity tables are available from film manufacturers.) Development time has its greatest effect on high values, but also affects low values. Both negatives were printed together by contact on normal paper.

the normal grade No. 2. But the problem inherent in the negative cannot always be solved by a change in paper grade. For instance, if a high value falls above Zone VIII and the negative is developed normally, that value will be "blocked": It will print as a chalky gray regardless of the paper used or the amount of printing exposure applied because there is no high value separation in the negative. The soft paper will also reduce the separation in shadows, where there is little separation at best.

A low contrast negative printed on high contrast paper also reacts differently from an expanded negative printed on normal paper. The expansion of the negative separates all values throughout its range to some extent, but the high contrast paper affects mainly the highest and lowest values. Negative expansion is thus indicated when a subject is com-posed of a number of closely related middle values. This would include subjects such as rock faces all in the sun or all in shade, woods in fog, portraits of men in shade, and so on.

Control of tonal values is within the grasp of all since it is quite mechanical and easily learned. It is the basis of pre-visualization. Armed with total control of print values, the photographer is free to expand his visualization in conceptual, compositional, and personal directions.

AUTHOR'S NOTE

Because I am more comfortable with a large format camera and it is well suited to much of the work that I enjoy, many of the photographs in this book were made with such equip-

NOTE: Many photographers enter the meter dial reading or foot-candles in the boxes, but I find it more useful to enter a symbol for the subject. My symbol for sun is ⌣ ; for shade ⌒ ; and the the letter relates to the subject. In this case, R⌣ means "rock in sun," R⌒ is "rock in shade," W is "water," and S⌣ is "stump in sun." There are spaces for additional notes on the back of each page.

SHEET NO.		PLACEMENT OF SUBJECT INTENSITIES ON EXPOSURE SCALE												EXPOSURE RECORD					
FILM T-X	REL.LENS STOP F/	64	45	32	22	16	11	8	5.6	4	2.8		Designed and Copyright by						
SIZE 4×5	REL. EXP. FOR V	1/32	1/16	1/8	1/4	1/2	1	2	4	8	16		ANSEL ADAMS						
DATE LOADED 7/15/68	REL. EXP. FOR I	1/2	1	2	4	8	16	32	64	128	256		Morgan & Morgan, Inc. Publishers						
DATE EXPOSED 7/16/68	WESTON SCALE	-	U	-	-	A	↓	C	-	O	-								

NO.	SUBJECT	ZONES	0	I	II	III	IV	V	VI	VII	VIII	IX	FILM SPEED A.S.A.	LENS F.L.	EXT.	x	FILTER NO.	x	STOP	EXP.	DEVELOPMENT
1	SIERRA POND					W	R⌒		R⌣	S⌣			200	5	—	—	—	—	22	1/30	N
2																					
3																					
4																					
5																					
6																					
7																					
8																					
9																					
10																					
11																					
12																					

ment. Photographic principles, however, are the same regardless of the camera used. Each photographer should use the equipment best suited to his way of working and to the subject matter at hand. In the same vein, the photographs in this book might be classified as "straight" photography. Photographers with a different way of seeing will have their own thoughts regarding choice of subject matter or approach. Here again, the photographic principles are not in conflict. The photographer who has mastered a controlled "straight" technique is technically equipped to utilize his creative gifts in his own way.

Accurate records of placement, exposure, filter, lens employed, and negative development are of the greatest aid to me. If a negative turns out badly, referring to the record may indicate the reason; if it turns out well, the record shows how it was made, and in either event, something of value has been learned.

For years I have used the ingenious "Exposure Record" (Morgan & Morgan) by Ansel Adams to record each exposure. Not only helpful in locating possible errors, it is useful before the exposure is made because it graphically indicates the tonal design of the photograph. The notation referring to the first illustration is reproduced here.

This book deals in large part with technical approaches to specific subjects. There is a danger, therefore, that the reader, especially if new to the medium, may be overly influenced by the emphasis on technical considerations. But unless the photographer is emotionally involved, his finest print from his most perfect negative will be no more than an exercise in sensitometry. Just as a computer will never be able to recreate the magic of a Bach fugue, or a chimpanzee create a work of art by mistake, so a photographer interested only in technical virtuosity will never make emotionally moving photographs.

The more personal intuitive steps that follow technical control are a result of the individual's application, sensitivity, and conviction. These next steps, the more ethereal areas of previsualization, are the subject of this book. In this area, no formulas are involved, no rules can or should be written. It is very difficult to teach photographers what can only become instinctive with experience. Workshop students tell me that the greatest help in appreciating these more elusive elements is a session that I think of as "Speaking of Photographs." Each student describes the concept, approach, problems, equipment, materials, and any unusual methods he used to produce a specific print. The others then discuss alternate paths the photographer might have followed to change the emphasis, strengthen the image, or produce a finer technical result.

In my teaching experience, photographs made to illustrate a single principle are difficult to relate to, whereas techniques used in situations familiar to all can be more easily absorbed. For that reason, with the exception of a few commercial photographs, none of the pictures chosen for reproduction here were made with publication in mind.

Since there are so many contingencies common to even the simplest photographs, only two or three main points can be profitably explored in any one picture. You will see that the pictures have been sequenced in such a way that any confusion generated by less than full explanations in the first few photographs will be cleared up by additional explanation in a subsequent picture description.

Though a photograph may be the statement of its maker, no photograph is the final statement on any subject. The possibilities of personal expression are infinite. My hope is that, as in a workshop, you are stimulated to think about and develop the photographic approaches that will strengthen your own unique way of seeing.

Table of Contents

SPEAKING OF PHOTOGRAPHS 5

 Introduction 5

 Normal Negative Development Time 6

 Plus Development 7

 Minus Development 8

 Author's Note 9

THE FINE PRINT 12

PERSONAL PHOTOGRAPHS 129

SUMMARY

 Cameras 151

 Meters 151

 Tripods 152

 Lenses 152

 Enlargers 152

 Enlarger Characteristics 153

 Darkrooms 153

 Filing System 154

 Films, Papers, and Developers 154

TECHNIQUE REFERENCES 157

High Sierra 1968

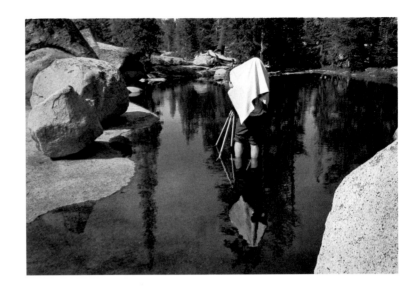

Many subjects can be photographed from any distance or any direction with the camera at any height from ground level to as high as the photographer can position himself. The infinite variety of viewpoints available practically guarantees that the photographer who sets up hurriedly or with an eye to comfort will not achieve the most effective positioning of the camera.

Precise camera placement, especially for subjects at less than infinity focus, is of enormous importance. In portraiture, raising or lowering the camera, even an inch, will change the perspective. Moving the camera right or left will change the head shape, displace highlights in the eyes, accentuate or modify a jutting chin or a long nose. Increasing the camera-to-subject distance will flatten the features, regardless of the lens used.

In photographs of still subjects, a good way to locate a camera position that will result in a strong expression of the scene is to (1) assume that you are in the wrong place; (2) walk slowly around the subject with one eye closed looking hard at the changes that occur as foreground forms move closer to, touch, cross over, and then reveal again the elements in the background; (3) then, when you feel you have found the direction the photograph might be best taken from, walk toward the scene along that line still looking carefully as extraneous detail is obliterated underfoot and all around; and (4) when you have found the distance that feels right, (5) do a slow deep knee bend to find the proper height. All of the forms will change relationships drastically. Carefully study the scene with one eye closed. Your quickened pulse will tell you when order has appeared out of chaos.

If a tripod can be used, it should be. Place your head in the camera position you have decided on and set up the tripod with one leg pointing straight at the center of the desired image. Crank up the tripod head until your chin is resting on it. Now fasten the camera to the tripod and make small final adjustments of height, distance, or left-to-right positioning. Persistence and stubborn rejection of compromise in locating camera position are essential. The photographer must control the image.

The photograph of me (freezing) was made by Liliane De Cock (laughing). The hard-earned negative reproduced here is the best of four; the others were made from more comfortable locations around the pond.

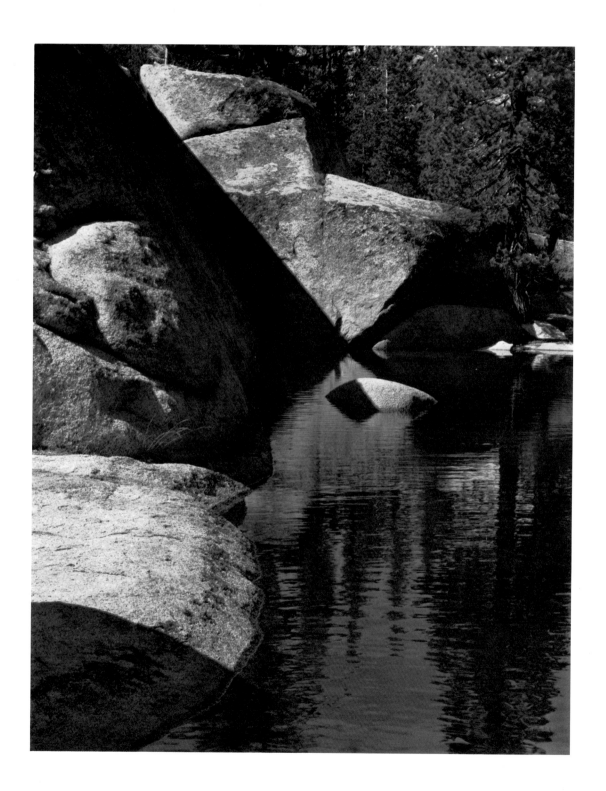

Deserted House Putnam County, New York, 1972

This house was awaiting the wrecker's ball. A week after the photograph was made the house disappeared and construction of a diner was underway. It must have been a beautiful home a hundred years ago. The place seemed inhabited by those generations that had lived there; the almost tangible feeling of presence was very strong.

Several techniques are available that help convey an impression of presence, substance, and touchability. In this instance, the camera was set up at eye level to create a realistic viewpoint. A sharply detailed texture very close to the lens causes a photograph to "read" well. The peeling layers of paint in the near window frame makes the same texture in the far window frame believable, although it is too far away for the lens—or the eye—to see clearly. Looking through the open window and on through the open door greatly strengthens the impression of depth, as does the strong convergence of the right hand wall toward an invisible vanishing point.

Three elements, then, controlled the camera position: the near window frame, the far window frame, and the door seen through the doorway. The camera was moved to the right as far as possible without obscuring the closed door. Then the camera was moved straight forward to approach the window frame. This forward position was subsequently abandoned, since it increased the area of the second well-lit window to a point where it overwhelmed the more delicate elements.

The 4" x 5" view camera back was swung away from the right-hand wall. (For vertical surfaces, the back or lens is swung; for horizontal surfaces the back or lens is tilted.) This not only increased the depth of sharp focus, which now extended in a plane from the right-hand window frame to the far left corner of the room; it also increased the convergence of the right-hand wall, accentuating still further the sense of depth. Stopping down the 90mm Schneider Super Angulon lens to f/32 was sufficient for sharp recording of the closed door, which fell beyond the plane of sharp focus.

The large dark area of exposed brick in the corner was placed on Zone I, the first step above black. Other interior surfaces were metered and they fell on Zone II for the open door to Zone VI (traditional for fleshtone) for the far window frame. But the white plastic curtain fell on Zone IX and would appear as chalky, textureless white. Decreasing the exposure to lower the plastic to the desired Zone VIII would have lowered all of the other values one Zone. This would have been unacceptable, so a minus development was decided upon. Reducing negative development time reduces the denser areas much more than the thinner (less exposed) areas of the negative. The Normal −1 notation on the exposure record would insure that the Zone IX placement would be developed to a Zone VIII density.

In a print that is dominated by a group of rich middle grays, a small amount of pure black and pure white will key the mass of grays and add brilliance. If these black and white areas are adjacent to each other, the effect is maximized, as in this photograph.

The exposure meter indicated eight seconds at f/32 for Tri-X film. The actual exposure was for 24 seconds to compensate not only for the reciprocity effect of exposures longer than one second, but also for the short development time. (Reciprocity tables are available that indicate the increased exposure necessary, but careful workers make their own tests.) The print was made with a wall-mounted Omega D-2 Enlarger modified with a Cold Light Head. (This equipment —see *The Zone VI Workshop*—was used to make all of the prints in this book except one where a condenser head was substituted for a special effect.) The paper was Varigam, developed in Dektol diluted 1:2 and slightly toned in diluted selenium, which cools the greenish color and adds a surprising spatial element to the print. Print manipulation was slight. The floor was lightened a bit by fluttering a dime-sized dodger over it during one-half the exposure time.

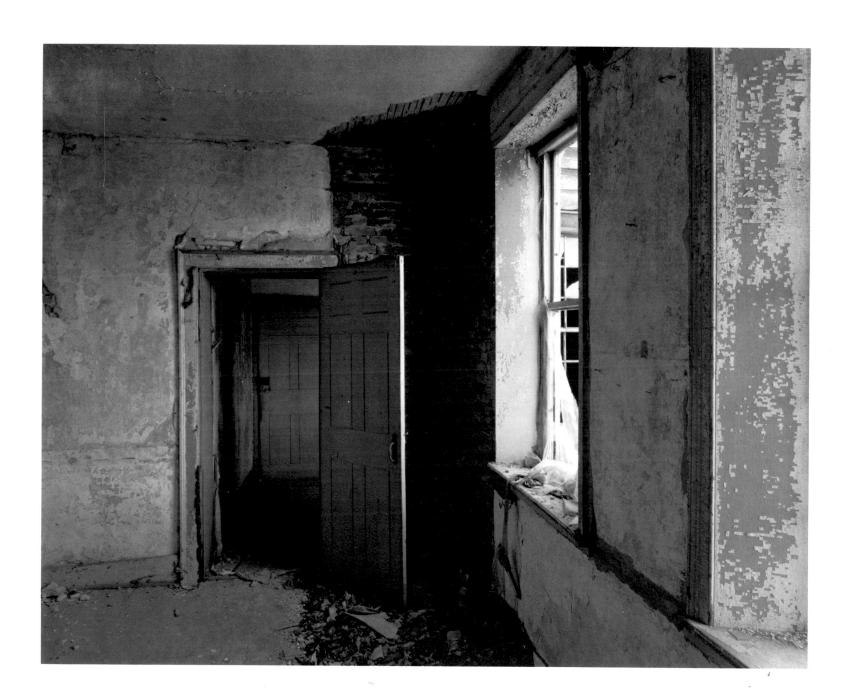

Tobacco Sheds Massachusetts, 1970

At the time an exposure is made the photographer experiences the greatest intimacy with that particular subject. At no later time will he be more in tune with the image that moved him to photograph; for that reason I find that there is no better time to design the final print. When I made this exposure I wrote in my notebook, "Tobacco Sheds—print it big, print it monotonous."

The brightness range of this subject was very short. The difference in light reflected from the buildings and the field was only one stop. The sky was lighter by one stop (Zone) than the field. A K-2 filter was used to darken the sky, enhancing the lonely, monotonous atmosphere. The structures were placed on Zone IV, the field fell on Zone V, and the sky, which fell on Zone VI, was reduced to Zone V by the filter. The exposure for the hazy sunlight was 1/25 sec. at $f/22$. Because there was no wind and the grass was still, it would have been possible to stop down further and use a slower shutter speed, but the lens used, a 210mm Schneider Symmar, is not as sharp at $f/32$ or $f/45$ as it is at $f/16$ or $f/22$. With a bellows camera like the Sinar, great depth of field can be achieved in pictures of this type without stopping down by simply tipping the lens forward until both the near foreground and, in this case, the barn roofs appear tack sharp on the ground glass.

The Tri-X negative was tray developed for seven minutes in HC-110 dilution B. (Seven minutes used to be my normal development time for Tri-X, but at present my normal time is five minutes. Films change.)

An 11" x 14" print was made on No. 2 Kodak Medalist—the most monotonous paper I know of! Printing controls were limited to 10% extra exposure at the edges to smooth out the values. This is helpful in most prints to counteract the light loss from the enlarger due to the greater distance from the enlarging lens to the edges of the print. Other factors that weaken print edges are inherent in the negative. They include flare light bouncing from the camera sides, which adds edge density by exposure. Agitation of the negative in the developer is always greater at the film edge regardless of the agitation method used. This increased agitation of the edges further increases their density.

The print was developed for only one minute and fifteen seconds in Dektol diluted 1:3. My usual development time is two minutes in Dektol diluted 1:2. Thin dilution and short development time reduce print contrast.

Any technical manipulation is valid to achieve the creative intent and any rules that inhibit a worker's freedom should be discarded. Rules are often imposed by photographic writers and manufacturers of materials and equipment, and, if followed, might be contrary to the photographer's desired statement. One generally accepted rule dictates that low contrast negatives be printed on high contrast paper and vice versa. This rule was ignored here. Rules such as these may or may not result either in an accurate reproduction of the scene or an expression of the photographer's feeling for the atmosphere.

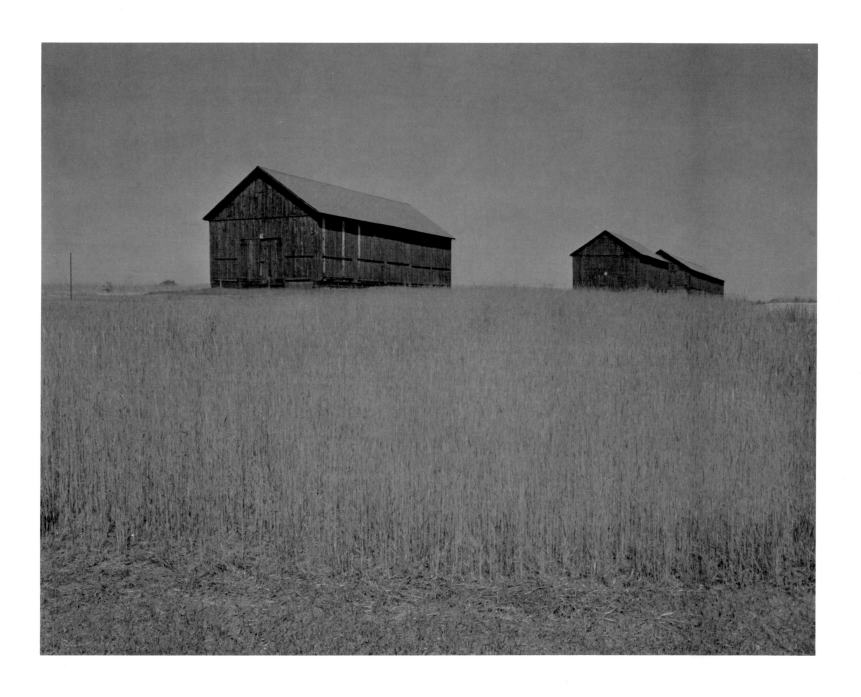

Searsport, Maine 1973

Photographers love a photogenic subject and sometimes there are scenes that just shout for recording because of the certainty of a beautiful print. I find joy in subjects that "show off" the strengths of my adopted medium even when my emotional involvement is not profound.

For this shot there were no problems and few decisions to make. The camera position was chosen for comfort; the tripod was set close in front of a stump so I could sit while focusing. It was a chance to use my finest lens—the incredibly sharp Goerz Red Dot Artar of 12″ focal length. (Although purchased used, it cost more than a good second-hand car.) There was no hurry. The light would last for hours and the puffy clouds would keep marching across the hilltop. I focused sharp on the ground glass and added the No. 12 filter, which would darken the sky slightly and clear what little haze there was in the air. The meter was unnecessary. I knew from experience that on such a day, the Tri-X film exposure is 1/125 sec. between $f/16$ and $f/22$ with the filter.

Each year, when my lenses come back from their annual checkup by the good doctor (Marty Forscher's Professional Camera Repair), the health chart for the 12″ Artar lens reads the same: "Indicated shutter speed 1/200, actual 1/125." I therefore set my old Ilex shutter at 1/200 sec. so that it would fire at 1/125 sec., cocked the shutter, put the film holder in, took the slide out, and fully extended the bellows sun shade. Every control was at the normal position. Sitting on the stump, with a three-foot cable release in hand, I shot several exposures as insurance against defective film or processing damage.

The negative was given normal development. A contact print made for record keeping was exposed for the minimum time that will render clear film—the film edge—as maximum black. This "proper proof" showed that each tonal value was reproduced as visualized. (See *Zone VI Workshop*, p. 38.)

The first step in making the enlargement was selecting the test strip exposure that showed the distant houses pure white and the clouds cottony. A trial print at that exposure indicated that the whites would show more brilliance if the river was slightly darkened. About 20% of the basic exposure was added to the river. The edges were burned 10% and the print just glowed. The final print was made 11″ x 14″ on Ilfabrome No. 2, developed 4½ minutes in Amidol.

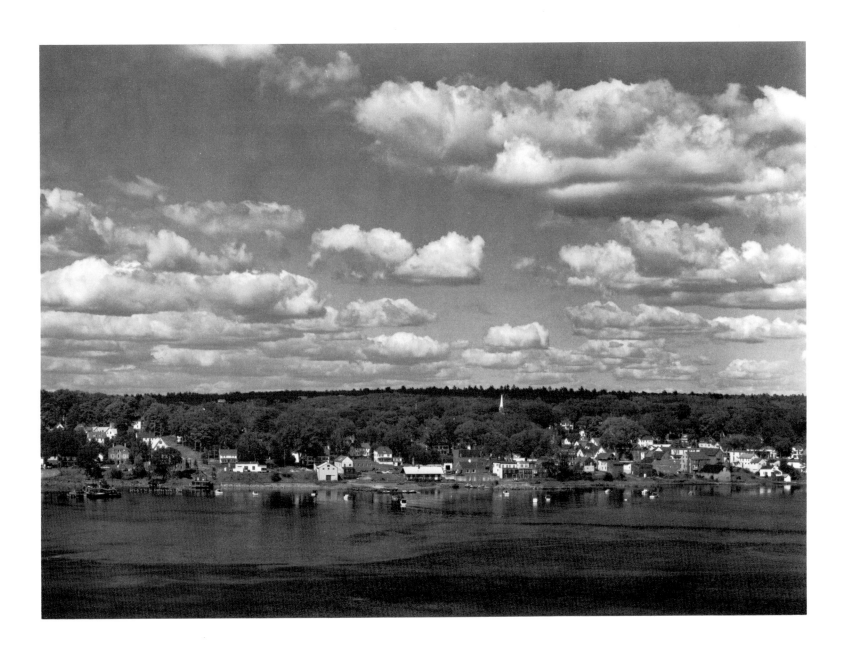

Sebastian Pakarati Ika Easter Island, 1973

Sebastian is an important man, the Mayor of Easter Island. Although self-effacing to the point of shyness, he possesses an intangible quality of leadership that sets him apart in a group. After I knew Sebastian for several weeks, it became apparent to me that discharging the duties of Mayor is what he does and not at all what he is. He is a farmer, a fisherman, a man of the earth.

This photograph was made just after Sebastian had landed his fishing boat. He was not comfortable before the camera so the fast hand-held 35mm Nikon with a 105mm lens was used. With it, I could make the three exposures permitted in less time than it would have taken to set up the 4″ x 5″ camera on its tripod.

The large camera can be effective in photographing some portrait subjects because the time required and the impressive size of the equipment give importance to the photographic event about to take place. It is, however, difficult to generalize regarding the best combination of subject and equipment. Bruce Davidson's superb view-camera portraits of ghetto dwellers in *East 100th Street* are perhaps more intense and surely different than if the subjects had been photographed with a hand-held camera. The photographer must instinctively make the decision as to whether the subject will be best presented if the photographic atmosphere is informal and the pictures more spontaneous.

Regardless of the equipment, flesh tones, to be convincing, must be presented with a feeling of substance in the print. Many of the portrait prints that fail to impart a "touchability" are characterized by chalk-like flesh tones lacking delicate tonal gradation or smooth high values. This deficiency is usually caused by one of the following factors:

1. Negative underexposure, which requires a high contrast paper to print some black and elevate the high values.

2. Overexposure—equally damaging because the delicate high values are crowded together on the shoulder of the film's characteristic curve above the straight line.

3. Overdevelopment of the negative or use of developers such as Microdol or D-76; both cause an early "shoulder" of the characteristic curve, crowding the high values together.

4. Condenser enlargement, which reduces high value separation and produces chalky tones.

5. Overenlargement, which causes deterioration of smooth tonal values, increased grain size, and loss of sharpness.

The negative was made on Tri-X 35mm film rated at my exposure index of 200. The flesh tones were placed on Zone VI. The exposure was 1/125 sec. at $f/11$. The film was developed for my normal five minutes in HC-110 dilution B. A 4″ x 5″ print was made on No. 2 Ilfabrome paper developed five minutes in Dektol diluted 1:2.

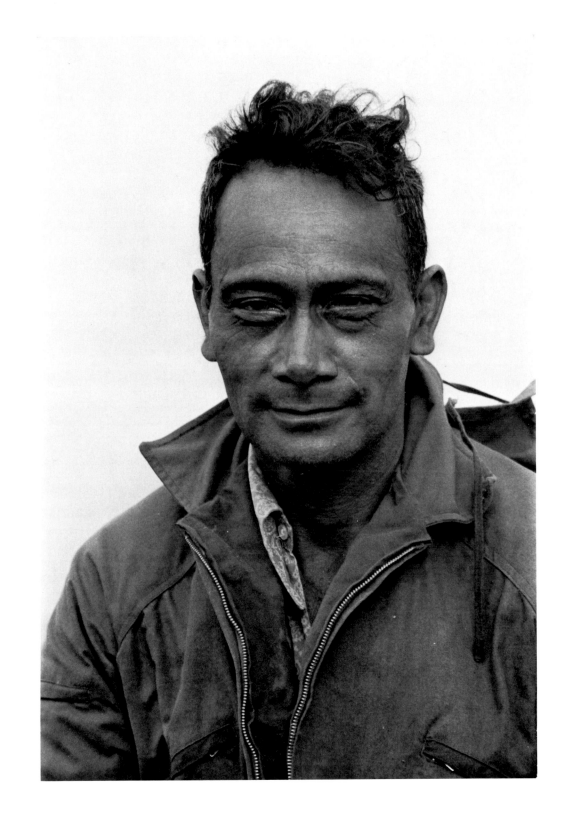

Double Portrait White Plains, New York, 1973

The difficulties of portraiture multiply alarmingly as the number of subjects is increased. It becomes a greater challenge to get the poses, the expressions, and the lighting all working together.

The task is generally made simpler if the subjects are placed in full shade, because in the sunlight a slight movement of the head can light up a nose or paint a distracting white patch on cheek or chin. If portraits are done in the shade, eliminating the sunlight problem, then a full frame close-up should be made. The close-up position allows the prominent highlights in the eyes, cheekbones, and teeth to brighten the print. If the head does not occupy a large area in the image field then these highlights occupy too small an area to be effective and the resulting print is apt to be drab.

In this case my difficulties were compounded because an extreme close-up of these young people seemed inappropriately dramatic and I was therefore forced to include direct sunlight to add brilliance to the print. Covering the sunlit areas demonstrates the necessity for this decision.

A fine new camera was used for this picture. The Pentax 6 x 7 camera provides a $2\frac{1}{4}''$ x $2\frac{3}{4}''$ negative, which requires less than a $3\frac{1}{2}\times$ enlargement to make an 8″ x 10″ print. The camera looks and handles like a large 35mm reflex. Its added weight helps to counteract the substantial slap of the reflex mirror, which cannot be locked up before exposure. I regard the lack of mirror control and the poorly designed film-spool-removal buttons as the only faults in an otherwise sound, professional camera.

The flesh tones were placed on Zone VI, the rock in shade fell on Zone V, the white coat fell on VII and the boy's jacket on III. Sunlit areas were small and printed about Zone VIII. The exposure of the Tri-X film was 1/125 sec. at $f/11$. The camera was on a tripod with my hand on top of the camera to steady it against the mirror slap that always causes some loss in resolution.

The 12-second enlarging exposure was divided into four exposures of three seconds each. A tiny piece of window screen on a wire was flicked over each face during one of the three-second exposures to brighten the flesh tones slightly. All print edges were burned an additional three seconds. The print was made about 6″ x 9″ on Varigam with a No. $2\frac{1}{2}$ filter and developed two minutes in Dektol diluted 1:2. After four minutes in selenium toner mixed four ounces to the gallon, the print was washed, then dried face down on a plastic window screen. Finally, it was dry-mounted on Strathmore lightweight regular surface board cut 11″ x 14″.

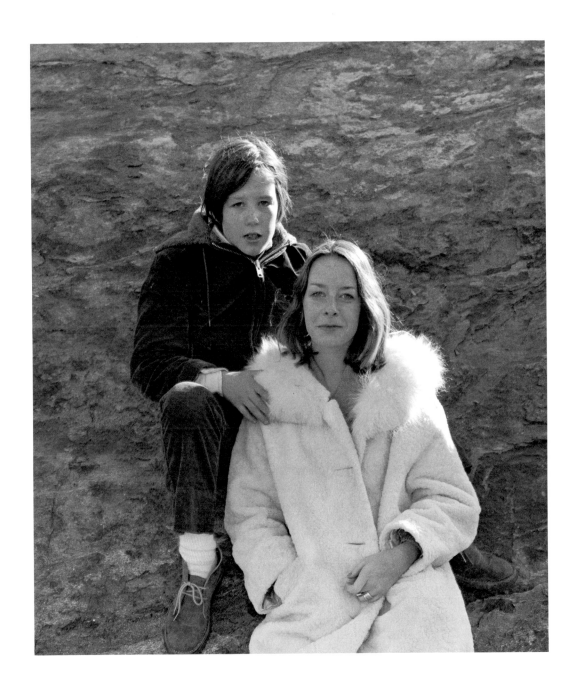

Gaspé 1972

The flowing shapes, lines, textures, and above all, the glow of light, make natural forms of this kind the particular province of photography. For me, the beautiful shapes require no interpretation. They demand emotional involvement, a certain clarity of vision, and a degree of craft if they are to be recreated in the silver image.

This photograph was made from a very low camera position and the area covered was about a six-foot square. The camera was placed to reveal the sun's reflection from the wet area of rock at the edge of the evaporating tidepool. This adds a sparkle to the print that serves to key the rich gray tones. Pure black appeared in some of the wet seams. This camera position helped place the downward curve of shadow in a harmonious relationship with the upward curve of shaded stone in the foreground. The shaded foreground areas were placed on Zone IV, the sunlit rock fell on Zone VI and VII, and the wet stone at the pool edge fell on Zone VIII and IX. The Tri-X exposure was 1/50 sec. at $f/32$. The negative was developed normally and printed "straight" (without manipulation) on No. 2 Varigam.

Sharp focus, in depth, with a view camera can be obtained in two ways without stopping down the lens. Sharp focus can be accomplished without introducing distortion by tipping the lens forward, but in this instance an alternate method was used. The same effect of sharp focus over an inclined plane (ground sloping up) can be achieved by first leveling the camera and then tilting the camera back to the rear rather than the lens to the front. This back tilt is not always desirable as it changes the size relationship of near and far objects. Objects closer to the lens are lengthened vertically and therefore loom larger on the ground glass—and in the print. For this picture, the distortion seemed desirable because the upward and downward dark curving forms appeared nearly the same size on the ground glass, giving the effect of being the same distance from the lens. By tilting the back to make the near form loom larger, the effect of receding depth is augmented, the composition is improved, and the sense of presence is increased.

The sense of presence is increased in any photograph by the impression of touchable texture. The quality and direction of the light on various surfaces are so important that they can make a rough surface appear smooth in a photograph. Here the high noon sun is skimming down the vertical surfaces and the stone textures are exaggerated. Each tiny rough projection casts a shadow. On the surfaces that face the light directly (left and right of the tidepool), the textural effect is sharply reduced, but the low camera position keeps these areas relatively small. The foreground shadowed area shows little texture, but since it is obviously the same rock, it "reads" as the same texture.

The print was made on DuPont Varilour paper with a No. 2½ filter. To cool the brown tone of this paper, benzotriazole was added to the Dektol developer.

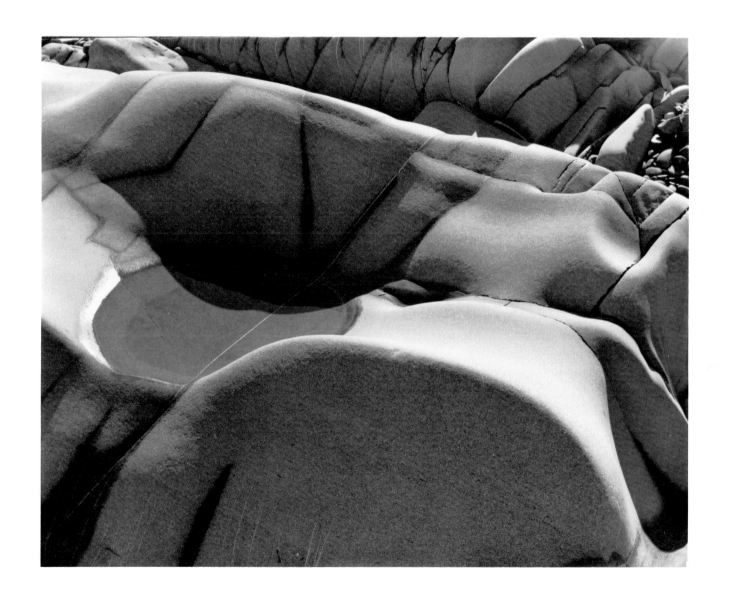

Great Dunes National Monument Colorado, 1968

A news photographer, asked the secret of his success, replied, "$f/8$ and be there." Photographs of fast-breaking news events and huge vistas would seem to have little in common, but the same "be there" rule applies. Big landscapes are among the most elusive subjects and sometimes it seems that every force of nature is conspiring against the photographer. He needs an unobstructed position for his camera, a quality and direction of light that will reveal and dramatize the forms before his lens, and sophisticated equipment set up and ready at the proper moment. If the news photographer's picture of fleeing bank robbers is a little underexposed, a trifle blurred, it doesn't matter much. In his case, the event is the thing. But the landscape photographer's negative must be close to perfect, because this subject matter requires a print of pristine elegance.

The runoff from heavy snows melting in the mountains covered the foreground area with a skim of water that might have been monotonous had it covered the entire area. Luckily, the thin layer of water permitted sand islands to rise and form beautiful shapes with rich variations of tone. The backlight brought out the sparkling highlights in the rippling water and wet sand. The sun was high enough to brush the distant dunes, revealing their smooth contours.

The feeling of space was augmented by use of a low camera position and a wide-angle lens. The closest grains of sand, wet and tactile, were in sharp focus. In order to include the dune tops in this field of sharp focus, the camera back was tilted to the rear. When it is possible to focus sharply on the entire scene by use of camera movements alone, the photographer has the advantage in choosing the optimum lens stop for sharpest rendition. Although the *depth* of sharp focus is greatest with any lens stopped down fully, such stopping down causes a diffraction effect that reduces overall sharpness. The 121mm Super Angulon lens used for this photograph is at its best at $f/16$ and $f/22$.

The exposure was determined by placement of the glistening sand on Zone VIII. The sunlit hills fell on Zone V, the dark sand on Zone IV, and the logs were below threshold and print pure black. With a spot meter, accurate readings of distant values are simplified. A light (K-1) filter was used to slightly intensify the shadows on the dunes and add some tone to the sky. Stronger filtration might have lowered the sky tones to a point of merger with the tops of the dunes, blackened the shadows, and probably would have created a harsh moonlight effect out of keeping with the existing light.

The exposure on GAF Versapan Film was 1/10 sec. at $f/22$. The film was developed normally in FG-7 developer and an 11" x 14" print was made on DuPont Velour Black Grade No. 2. The large shadowed dune faces and the wedge-shaped sand area at the lower left were dodged slightly.

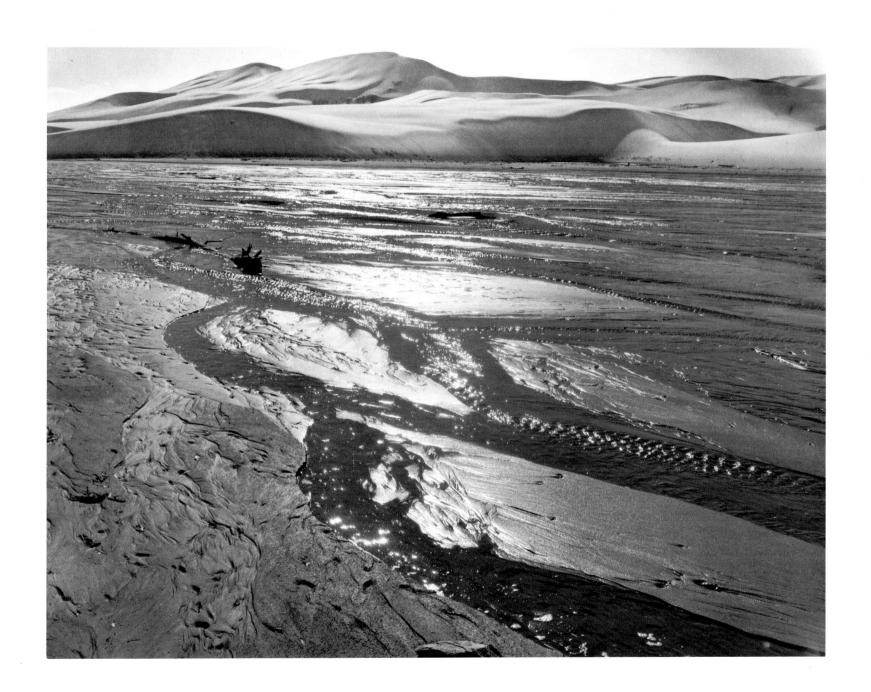

Ellsworth Bunker Farm Dummerston, Vermont, 1973

Driving from Putney to Dummerston one day, I saw a cloud that seemed to be growing out of the hill. I stopped to watch, realizing that it would be gone before a camera could be set up. Then another beauty materialized. The clouds were following each other, moving from right to left, appearing one by one from behind the trees. Setting up the Sinar with a 90mm wide-angle lens and No. 12 filter, I started to photograph each cloud as it appeared. It was an exciting parade, observed by the pale crescent moon in the center. With the wide-angle lens, the moon is so small that it really looks more like a negative defect.

Once the film holder is inserted in a view camera, the photographer can no longer see the image on the ground glass. When moving subjects are to be photographed, this is a severe handicap, but it can be overcome to some extent by noting objects at the edges of the picture area before the slide is inserted. For this picture my right-hand marker was the notch in the silhouetted tree. On the left a flat-topped bush on the horizon served as a reference. With the viewing filter used as a frame, the area included between the markers could be isolated. This substitute viewfinder gave a good indication of the way the clouds would be placed.

The exposure here was based on a Zone VIII placement for the brightest part of the cloud as determined with the S.E.I. photometer. This procedure does not follow one of the accepted rules of photographic technique, "Expose for the shadows, develop for the high values." In many instances I place the high value as high as possible. If the Zone VIII placement is too high for the subject, it can be printed down, but the important point is that the shadows will be better separated. There is no way to overdo this shadow separation, since the separation in print tones is much less below Zone V than between V and VIII.

The placement of the cloud on VIII required an exposure of 1/30 sec. between $f/22$ and $f/32$. The film was 4″ x 5″ Tri-X developed normally in HC-110. A 7″ x 9″ print was made on No. 2 Ilfabrome developed in Printofine for three minutes. This developer has an unusual ability to separate close values within the image without increasing the overall contrast. For certain types of work, such as portraits, my choice would be another developer, but for this negative Printofine worked well.

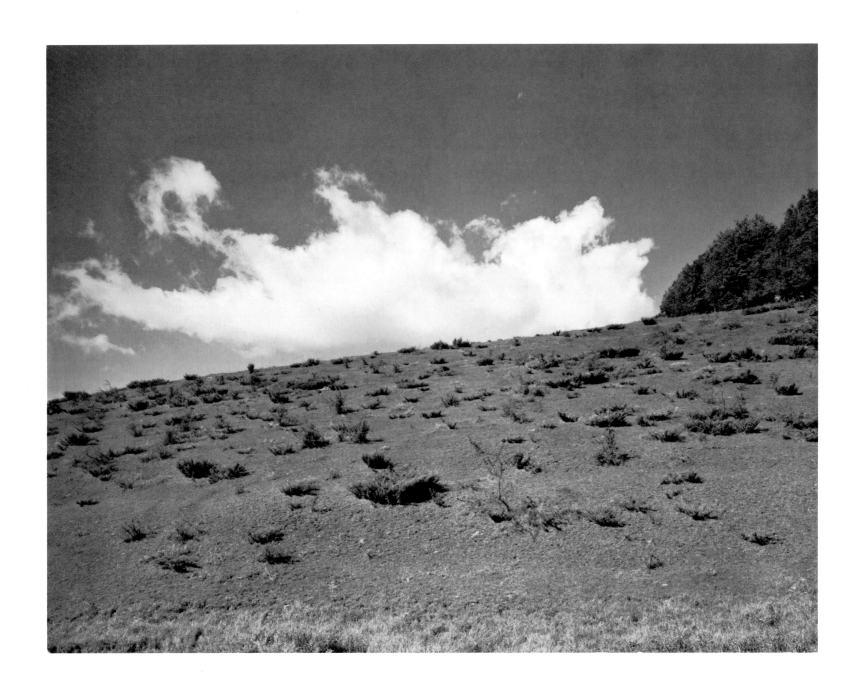

Ahu Easter Island, 1973

On Easter Island there are 250 huge stone platforms called *Ahus*. Their function is only a mystery to those who have never seen one. This visitor, peering among the tumbled rocks, had no difficulty in recognizing *Ahus* as burial chambers.

The skull gave me the impression of a pale, glowing white object in its shadowed crypt. If it was placed on Zone VI or VII to recreate the emotional impression then the sunlit rock would fall on Zone XII and would print chalky and harsh. Negative densities above Zone VII do not increase in proportion to increased exposure, so values above Zone VII pile up on this section of the film curve (called the shoulder), where delicate separation is impossible. Anyone who has seen the pasty white faces in overexposed flash pictures will recognize the problem.

Several solutions were available. The photograph could have been made later in the day when the sun would shine directly into the deep recess, reducing the contrast range; or, it could have been made on a gray day when the entire scene would be covered by even sky light. Neither of these solutions, though technically feasible, would be very exciting visually or communicate the emotional contrast between the sunny outer space and the dark, gloomy interior. Fill-in light from electronic flash, if available, might have solved the problem technically, but in most photographs where flash is employed to fill shadowed areas there is a definite sense that something artificial has been added.

The problem was solved quite simply. The white side of a five-foot-square focusing cloth was used as a broad diffuse reflector. With it, the sunlight could be directed to the skull, which now showed a three stop increase in value—eight times more light was now reflecting from it. Now, with the rocks on Zone VIII (they would be developed to VII), the skull fell on Zone V. Zone V is in the center of the film's straight line, where there is fine separation, so print manipulation is possible without the loss of detail. The skull could easily be dodged in the print to show print value VI. I aimed the reflecting cloth while Lillian Farber, who assisted me on the trip, made the exposure. The 4″ x 5″ Tri-X was exposed ½ sec. at f/45 and developed Normal −1, which reduced the value of the sunlit rock to Zone VII. The print was made on Varigam with No. 4 and No. 1 filters. The No. 4 filter provided the needed contrast between the skull and its dark surround. During that exposure, the skull was dodged to lighten it. The next exposure, utilizing the No. 1 filter, was made while the skull and shadowed rock were shielded. This reduced the value and softened the hard textures of the sunlit rock. An unmanipulated negative and print would have failed to convey the feeling of light on the rocks or the eerie glow of the skull in its dark chamber.

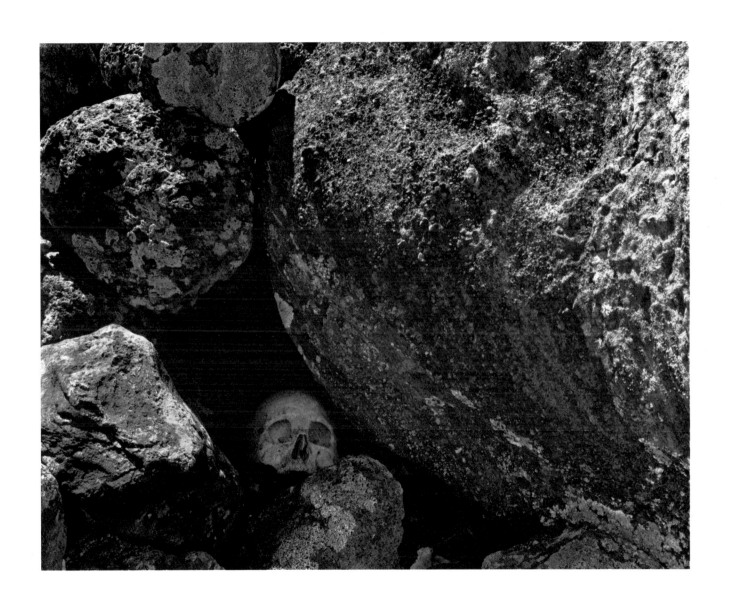

Ahu Akivi Easter Island, 1973

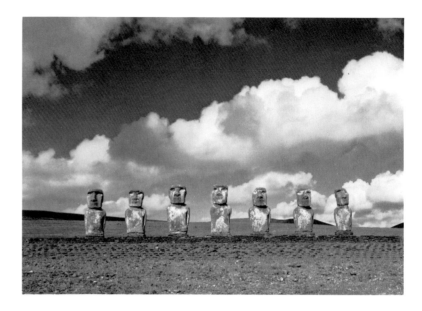

Powerful, exciting photographs require such a large number of balancing, contrasting, interacting elements that it is a wonder they happen at all. The odds are sometimes greatly reduced in favor of the photographer if he adds a simple ingredient to his technique: patience.

This group of sculptures, called *Moai*, was photographed for the book *Rapa Nui*; the upper photograph was the first one made. This *Ahu* is among the most important on the island and an ordinary record photograph would have been unacceptable. Despite the beautiful sky, the row of evenly spaced figures made for a static photograph.

After the first exposure, the film was replaced, the slide removed, the shutter cocked, and a long wait begun. Who has not had the experience of making a photograph, repacking the equipment, and then seeing an exciting improvement in the scene? Happily, this time the equipment was in readiness when the galloping horses appeared over the hill to the left. The first thought was to photograph them when they appeared between the *Moai*, but they were so spaced that one was always partly obscured when the other was completely visible. Afraid to get half of a horse, I waited until the front runner had broken into the clear and then tripped the shutter as the second horse appeared between the last two *Moai*. With a view camera, there is no way to tell ex-

actly what field is covered since at the time of exposure the film holder obscures the ground glass and the lens is closed. I was not sure that the leading horse was in the picture at all, but the negative showed all pieces in the right places.

The photograph was made on 4" x 5" Tri-X film developed normally. The *Moai* were placed on Zone V, the clouds fell on Zone VII. The lens was a 210mm Symmar, and a No. 12 (medium yellow) filter was used. The lens was opened $1\frac{1}{2}$ stops to compensate for the amount of light that the filter absorbed. This is a half-stop more exposure than is recommended for this filter, but the very blue light of the area required the extra exposure. Near East Coast cities, the light is quite yellow and passes so easily through a yellow filter that a factor of 1.5—merely an extra half-stop exposure—is usually sufficient.

The actual exposure was 1/25 sec. at $f/22$ and a 12" x 20" print was made on Varigam with a No. 3 filter. The foreground and edges were burned-in considerably—about 25% extra exposure, to help pull together the rather spread out composition. The distant horses stand out quite strongly in spite of their size for two reasons: They are the only objects that are pure black in the print, and the eye is attracted to small blurred areas in a sharp photograph or small sharp areas of a generally unsharp photograph.

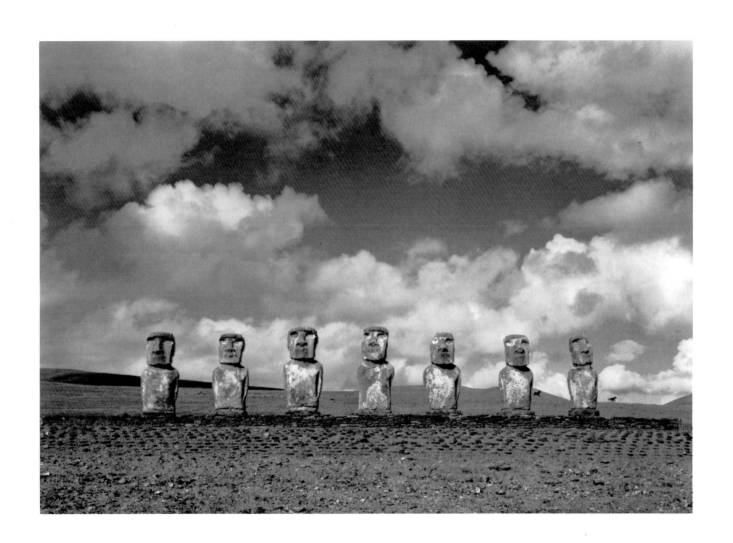

Altar New Mexico, 1969

Diffused light reflecting from white surfaces creates soft shadows and luminous tones. The diffused lighting here, however, is quite unusual. The left-hand figure is quite strongly illuminated by the direct light from the nearby window. That opening provides the main light source and is strong enough to extend to the right-hand figure and cast its shadow on the wall behind the dark window. The "fill" light of about one-half the strength of the light at left comes from the right window and casts a weaker shadow of the left-hand figure onto the side wall next to the brighter window. If both sources of light had been of equal intensity, there would be little dimensional modeling of the forms.

Interiors are usually realistically photographed with the camera at the eye level of a standing observer. In this instance, the camera was positioned at the eye level of a kneeling worshipper since this was probably the position from which the altar was most often seen. In order to preserve the linearity (avoid convergence) of the vertical lines of room corners, windows, and so on, rather extreme camera controls were required. First, the camera was precisely leveled front to back and left to right. This was easily done by observing the bubble levels with which all cameras should be equipped. Next, the camera was slightly rotated left to right until the horizontal lines of the subject were parallel. When that was accomplished, the frame did not include all the desired area, so the sliding front was moved slightly to the right. There were still more difficulties. The table tops (which were at the same height as the camera) were seen in the center of the ground glass; there was a great deal of floor showing;

and part of the cross was out of the picture. To solve these problems the lens was raised and the picture then appeared on the ground glass as shown. In old buildings of unusual construction it is sometimes impossible to get all lines straight.

Such extreme view camera movements require a lens of great covering power. The 121mm Super Angulon used here is capable of covering an 8″ x 10″ negative. This excess covering power permits extreme movements if the lens is only required to cover a 4″ x 5″ negative.

Since the lens focal length is only five inches, the infinity setting is just five inches from lens to ground glass. A normal accordion bellows would be so physically compacted that movements such as the rising front used here would be restricted. The soft bag bellows is therefore substituted when short (wide-angle) lenses are used.

The Versapan negative was exposed for 45 seconds at $f/32$ and developed normally in FG-7. The maximum printable exposure was desired, in order to lift all values as high on the straight line of the film curve as possible. Placement of the highest value, the left sleeve of the left-hand figure, was on Zone IX. This area of pure white serves to key the other values and add brilliance to the print. Its lack of texture is not objectionable because it occupies such a small area of the print. The important tones of the altar fell on Zones VI to VIII, the deep tones beneath the table fell on Zones II and III, and black appears in small areas in the right-hand figure. A 7″ x 9″ print was made on Varigam with No. 2½ filter. The only printing control required was edge burning of about 10% of the basic exposure.

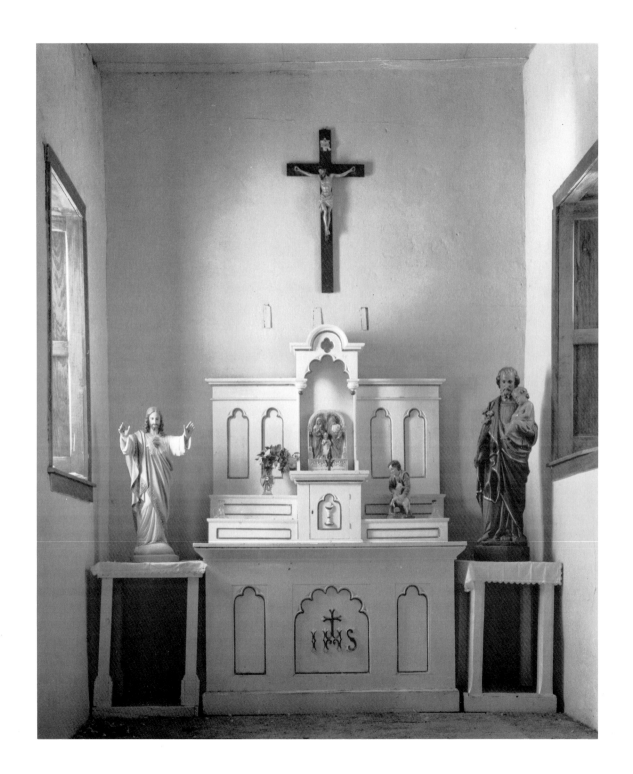

Church Door Dummerston Center, Vermont, 1972

Well-used structures, furniture, and tools have always appealed to artists. Those works that come immediately to mind include Andrew Wyeth's deserted breakfast tables and Paul Strand's barns and sheds. Pictures of these inanimate materials often tell as much about the people who use them as would portraits of the people themselves.

I saw in this church stoop order, cleanliness, pride in craft, and, in the flower gift, love. It is a well-worn old building. (The pipe rail was surely not on the original structure. It is a modern improvement that will never display the beautiful patina of use and age that the natural substances achieved.) Clear sunlight brings out the delicate tonalities inherent in the materials.

Sun and shade, though beautiful, are difficult to handle. Shadowless light shows planes and forms as they are (or as we think they are), but sunlight presents them as they look for a little while—changed by extraneous dark and light areas. The dark and light areas alter the composition, change the emphasis, and sometimes add a dimension of graphic design that the object by itself does not have. Here, the handrail's shadow joins the rail in the center of the photograph, creating a directional arrow of compositional strength. In addition, the shadow clearly indicates the space between the rail and the building. In shadowless light, the rail would appear as a black line painted on the building and the feeling of depth would be lost. (Covering the shadow with a card will illustrate this loss of dimension.) In the same way, the vertical shadow above the flowers defines the forward projection of the wide door frame. The clear sunlight skimming the vertical face of the granite step at an acute angle allows the surface texture to be most clearly seen. If the face of that step were not shown in the picture (or covered by your hand), the stone above would be difficult to identify as a different material from the wood.

The 4″ x 5″ camera was placed to arrange the small space between the pipe curve and the shadow. These nearly touching forms create a "tension point" as strong as the arrow point above. The camera was leveled and swung exactly parallel to the face of the building so that no horizontal or vertical lines would converge. The lens was then lowered and slid to the left to frame the desired area. Final focus was determined by focusing first on the close pipe elbow, noting the setting, then focusing on the door latch. The camera was then adjusted between the two marks, and the lens stopped down while the ground glass was observed. With the 121mm Super Angulon lens, everything became sharp at $f/32$.

The brightest value, the stone step, was placed on Zone VII, the white painted surfaces fell on Zone VI and VII, and shadows fell on Zone IV. The Tri-X exposure was for 1/25 sec. at $f/32$ and the negative was developed Normal +1 to further separate the textural values. The print was made on Varigam with a No. 2½ filter without manipulation except edge burning. Pure black appears only in the cracks between steps, pure white appears only in the largest flower.

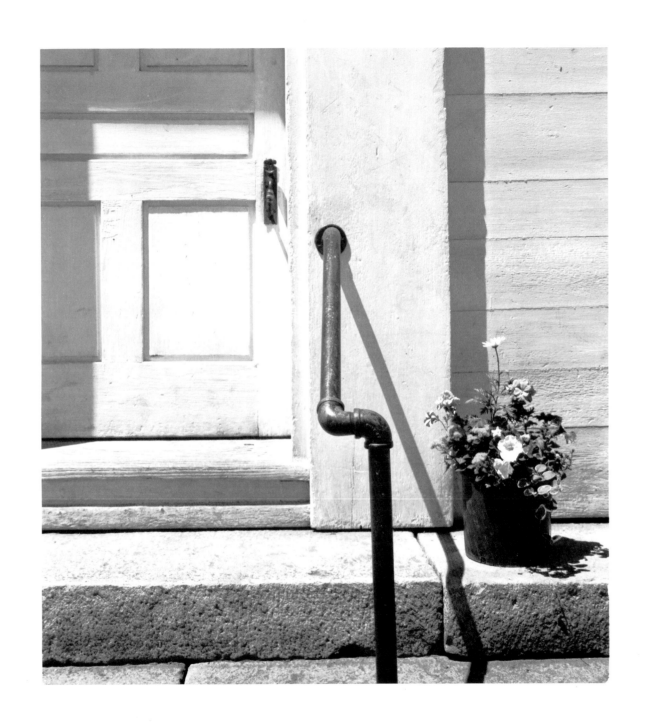

Quebec 1971

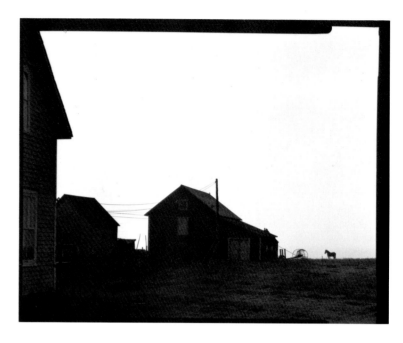

It is hard to imagine two photographs more different in intent and execution than this one and the previous photograph of the church door. Here, instead of rich detail, are textureless dark shapes against featureless white. The subjects are at an untouchable distance; the light is unreal. All sense of presence, depth, and volume is removed, and dimension is reduced to a distant flat plane.

Although the barn looms large in the finished print, its compositional weight is balanced on the other side of the photograph by the tiny but more provocative shapes of the hay rake and the horse. Small objects in large areas of strong tonal differences are powerful attractions to the eye. A speck of dust on a dark blue suit or a tiny black dot in the clear sky area of a print are annoying cases in point.

The camera was set up and the exposure made hurriedly in the pre-dawn light of a Spring morning. There was no time to change the 210mm (8¼″) Symmar lens and bag bellows that were on the camera: The lens covered more area than was desired, but changing it and the bellows would have taken several minutes. During that time, the horse might have changed position. The barns and meadows were placed on Zone III, but were subsequently "printed down" to a Zone II print value. The sky fell on Zone VI, but was shown in the print as pure white by use of a high contrast paper and a +2 negative development.

After the exposure with the 210mm Symmar lens, the camera was rearranged with accordion bellows, rail extension, and 300mm lens. By then the horse had turned straight toward the camera, presenting a lump-like, not horse-like, silhouette. He stayed in that position until the rising sun had added distracting, choppy light areas, so no other exposure was made. The longer lens would not have changed the effect of perspective—only a change in camera position would do that. The longer lens would, however, have provided maximum utilization of the negative area, resulting in a smaller enlargement ratio and greater sharpness. Only about 60% of the negative exposed with the 210mm Symmar lens was used. I try to avoid cropping, for it is inefficient and often a by-product of sloppy seeing. In this case, it was unavoidable.

A 4½″ x 7″ print was made on Varigam with a No. 4 filter and developed 2½ minutes in straight Dektol to increase contrast.

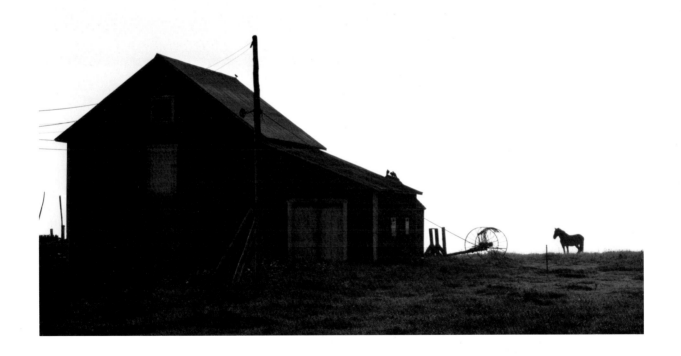

Gaspé 1972

The camera position was about one mile from the subject. At that distance it was impossible to meter the tiny buildings, so a substitute reading was made from the white side of my focusing cloth. The cloth was held at about the same angle to the sun as the buildings and it was metered along the lens axis. The textured cloth was placed on Zone VII. It could be assumed that the more reflective painted surfaces of the structures would then fall on Zone VIII.

Substitute readings can also be made of the palm of your hand (36% reflectance), which should be placed on Zone VI, or of a Kodak neutral gray card (18% reflectance), which is placed on Zone V. Such arbitrary substitute placements will provide "realistic" renditions of most "normal" subjects such as this. If a darker mood is desired, the indicated exposure is reduced; if a lighter, high-key effect is appropriate, the indicated exposure is increased.

A K-1 filter, sufficient to clear the slight haze, was used here. This very pale yellow filter darkened the blue of the sky and sea moderately while lightening the yellow-green of the grass. No alteration of values was desired here, only a correction of the film's inherent characteristics. Panchromatic films are not equally sensitive to all colors. Blue reproduces lighter than it appears—to the eye or the meter—and green reproduces darker. The subtle correction provided by the K-1 in high mountains and in lower areas of clear blue light seemed appropriate to me. Stronger corrective filters—K-2 or No. 12—are needed for realistic rendition in areas near cities or in any area where the light tends toward yellow. Still stronger filters such as the orange "G" or the stronger E-23 are helpful for a frankly dramatic rendition of a normal sky or a "realistic" rendition of a very white sky. It is my opinion that most errors in the use of filters tend toward over-filtration, which produces harsh moonscapes with black skies, empty shadows, and chalky-white high values.

Allowing a half-stop compensation for the K-1 filter, the exposure was 1/125 sec. at $f/16$; $f/16$ is the sharpest opening for my 300mm Artar lens. It could be used here because stopping down further for depth of field was unnecessary. The entire area of the photograph is at infinity.

The 4″ x 5″ Tri-X film was developed normally in HC-110 dilution B. The print was made on No. 2 Varigam (no filter). With a magnifying glass, the white dividers between window panes are seen to be perfectly sharp. This quality of definition requires fine optics on the camera and the enlarger. (The enlarger lens was a 150mm Schneider Componon.) The print was made about 7″ x 9″, which is less than a two times enlargement from the 4″ x 5″ negative; sharpness was therefore unaffected by print size.

Other factors greatly affecting sharpness are the sturdiness of the tripod, the alignment and sturdiness of the enlarger, the quality of the film, and the type of developer. To most people's surprise, fine-grained developers greatly reduce the impression of sharpness. Only a test comparing two developers has proved effective in convincing students of this fact. Comparison tests of slow films, reputed to be sharper than fast films can also be made. The results are not necessarily in accordance with manufacturers' literature.

Sierra Peak 1969

Massive forms seem more impressive if the lighting is simple. When I first saw the peak, the edges of the buttresses on its shaded side were catching sunlight, causing a jittery appearance. As the sun moved, the entire north face became shaded, which greatly simplified the shapes and lines. The rectangular shape of the shadowed area created such a strong form that it balanced the composition, which would otherwise have been overwhelmed by the visual interest of the sunlit side.

The sunlit snow is "on the edge" of being blocked. Though it shows a trace of tone on the upper slope, the snow field adjacent to the foot of the nearest rock face prints pure white. This area is very small and it is broken up by the trees and their shadows, so the toneless white is not objectionable.

Covering the left-hand side of this picture results in a surprising revelation. Although the snow in shade is actually a Zone V print value it appears very white. The contrast between the shaded snow and the dark rock results in the impression of whiteness. Remove your hand and look again at the whole picture. The shaded snow is now seen to be only a Zone V value. The impression of whiteness is the result of the knowledge that it is snow so it must be white.

The photograph was made from about a half-mile away with a 12″ Goerz Artar lens on a 4″ x 5″ camera. This lens is supposedly a process lens designed for close work, but its performance at infinity focus is outstanding. To preserve as much lens resolution as possible, I have fitted a "U"-shaped bar to the back of each of my lens boards. It extends flush with the rear of the lens so that a small magnet can hold a gelatin filter close to the back of the lens. This arrangement is most advantageous for several reasons: A thin gel is superior to even the finest glass in preserving lens sharpness, and the rear position inside the camera protects the filter from light reflections and keeps it from being moved by the wind.

The photograph was made on Tri-X developed normally. The sunlit snow was placed on Zone VIII, the sunlit rock fell on VI, the dark rock on III. The reflectances were measured with a 1° spot meter. A 10″ x 12″ print was made on Varigam No. 2. The impression of height in the photograph is augmented by the size of the print, the vertical format, and the placement of the peak close to the top margin.

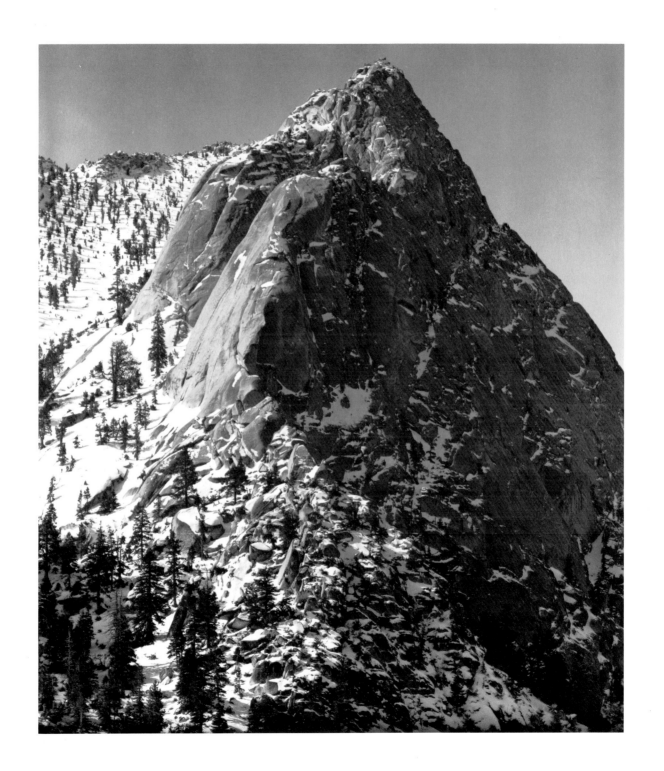

Storage Tank Connecticut, 1968

This photograph of a gas storage facility was made for an annual report. The client wanted a rather stark and graphic approach emphasizing the strong forms and minimizing extraneous detail. Several hours were spent locating a group of structures that could be organized into a clean composition.

Precise camera positioning was necessary to line up the small black opening of the horizontal pipe at the lower left with the last stair shadow on the tank, to place the distant valve between stair shadows, and to create a "tension point" at the intersection of the roof line with the curve of the stair shadows. The shaded side of the shed was then metered and placed on Zone II, three stops less than the meter reading. The white tank was next metered and it "fell" on Zone VII, two stops above the meter reading. Zone VII is a light but not "blazing" high tone. Zone VIII, an almost pure white, was the desired tonality.

Overdevelopment of the film would be required to brighten the tank and raise its value from Zone VII to Zone VIII. Such overdevelopment has little effect on the low values, so the overall contrast between lights and darks is increased. The film holder and exposure record were therefore marked "N + 1" (normal development plus one Zone) to remind me to develop this negative for eight minutes rather than my usual ("N") development time of five minutes.

The camera was a 4″ x 5″ Sinar standard with 121mm Schneider Super Angulon lens. The camera was leveled left to right and front to back to avoid converging vertical lines. The lens was then raised to frame the composition and tilted forward to focus sharply on the plane that included the weld on the foreground pipe and the top of the staircase. A No. 12 (medium yellow) filter was used to darken the sky and shadows. Stopping down the lens to $f/45$ brought the distant valve into focus and the Tri-X film was exposed for 1/10 sec. This generous exposure—one stop more than the meter indicated—was necessary to counteract the light-stopping characteristic of the filter.

The print was made on DuPont Varigam double-weight glossy, designated VGTW. This is a variable contrast paper, and filters can be employed above or below the enlarger lens to change the contrast between grades No. 1 (soft) and No. 4 (contrasty). For this negative, no filter was needed. The paper without filtration prints as a No. 2, which is considered normal. The paper has deep blacks and pure whites, and when toned in diluted selenium it achieves an attractive hint of cool purple. The print developer was Baumann Printofine, which delineates close values without increasing overall contrast.

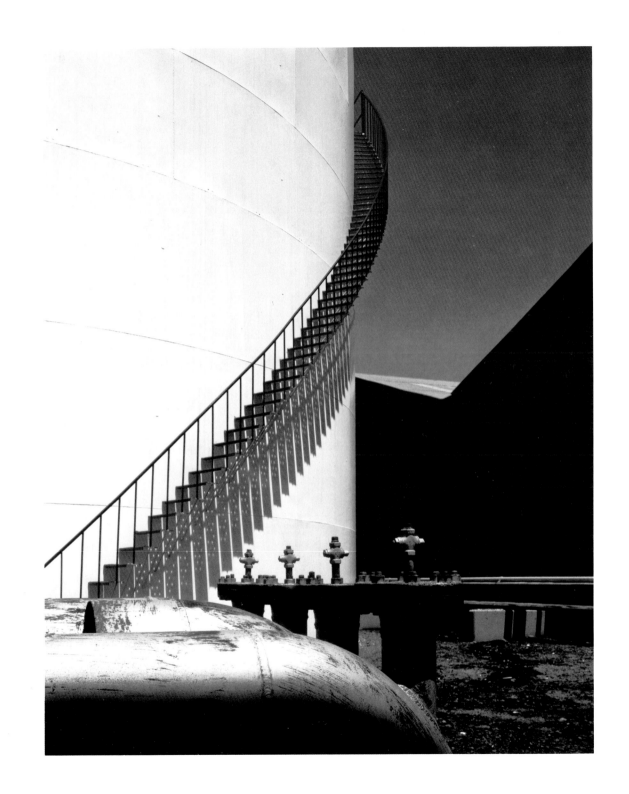

Massachusetts Coast 1974

The massive boulder seemed threatening and ominous, and appeared to hover above its base. To augment this illusion, the height of the camera was carefully adjusted to place the boulder almost wholly into the sky. A slightly lower camera position would make the boulder loom even larger, but it would also show the point of contact between the boulder and its base. From the chosen position, the sea appears to merge with the shadow line under the stone. This heightens the illusion that the boulder is somehow floating. The important contact juncture, or lack of it, is strongly indicated by the arrow of light sky aimed at the base of the rock. The top of the rock was brought close to the top of the frame to increase the feeling of bulk. Generous print size is also effective in this regard.

The shape of shadows as forms seldom have the impact in the field that they will have in the print. The great range of brightness that the eye can encompass is beyond the range of the film, and elements that appear distracting to the eye may not even appear in the photograph. Conversely, areas not noted by the naked eye may be of great importance to the photograph.

Two-dimensional tonal seeing is greatly simplified by the use of a viewing filter. In addition to framing the composition, it reduces tones, shadows, and colors to the approximate values they will achieve in a black-and-white photograph. In this case, my viewing filter showed: (1) the blue sea tonally merging with the shadow beneath the rock; (2) the dark shadow extending down the concave face of the boulder making it appear as two boulders, one advancing behind the other; and (3) the strong compositional balance provided by the interesting shadow shapes at the lower right. These might have been excluded to the detriment of the photograph if their importance had not been seen through the viewing filter.

Lacking the filter, one can at least frame the scene by forming a rectangle between the hands—one thumb up and one thumb pointing down. If the photographer then closes one eye and squints through the other, shapes and tones can be more easily related without the distraction of literal fact.

The shadowed face of the large rock was placed on Zone III, the sunlit rock fell between Zone V and VII. The sea fell on Zone III, but the No. 12 filter reduced it to a Zone II value. The exposure indicated was 1/30 sec. at $f/32$, but because of the filter the required exposure was 1/15 sec. at $f/32$. The photograph was made with a 121mm lens on Tri-X 4″ x 5″ film developed normally in HC-110. The 11″ x 14″ print was made on Ilfabrome No. 2 paper developed five minutes in Dektol 1:2. The sunlit wedge of the boulder was lightened by slight dodging to make it appear to come forward, reinforcing the impression of space and depth as well as the sense of hovering mass.

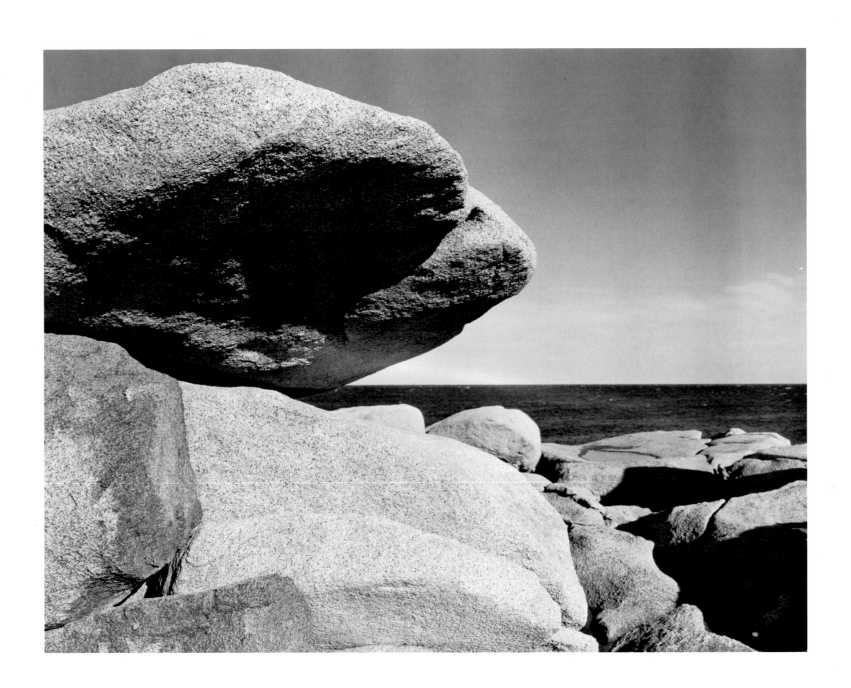

Massachusetts Coast 1974

Which is the primary form here? Which is the positive space? If you squint you may decide that the primary form is not the stones, but rather the hooked shape of the sky.

A slight change in the camera position would effect great changes in this picture. A fractional move to the left would close the tiny opening at the top of the white triangle. That tiny opening prevents the white triangle from appearing as a design painted on the rock. A further move left would entirely eliminate this triangle of light. Moving right would open the slot and destroy the arrow shape. Since the large boulder and the flat rock on the right are on different planes (the boulder is nearer to the camera), the smallest change in camera position greatly alters the shape of the space between them.

When photographing *any* subject it is important to be aware of the effects of even slight changes in camera position; but still subjects generally offer unparalleled opportunities to explore different viewpoints. Look at the scene from different distances, directions, and angles. When you find a position that seems promising, set up your tripod, rest your chin on it, and observe the spatial and tonal relationships with one eye closed. When the desired position is finally determined, you can mount the camera and easily make minute adjustments of the tripod.

Here, once the camera position had been decided, tonal values became the main concern. The stone in shade was placed on Zone II, the sky fell on Zone V, and the clouds on Zone VIII. The backlit clouds near the sun were so bright that they showed great separation from the sky, which therefore required no filtration. Tri-X 4″ x 5″ sheet film was exposed 1/25 sec. at $f/32$. The lens was a 210mm (8″) Symmar. The film was normally developed. A 10″ x 13″ print was made on Varigam developed two minutes in Dektol 1:2. The enlarging exposure was eight seconds at $f/11$ with the cold-light source. In addition to the usual edge burning, the upper right corner was burned an additional two seconds, for the sun was at the right and the sky in that area appeared somewhat weak.

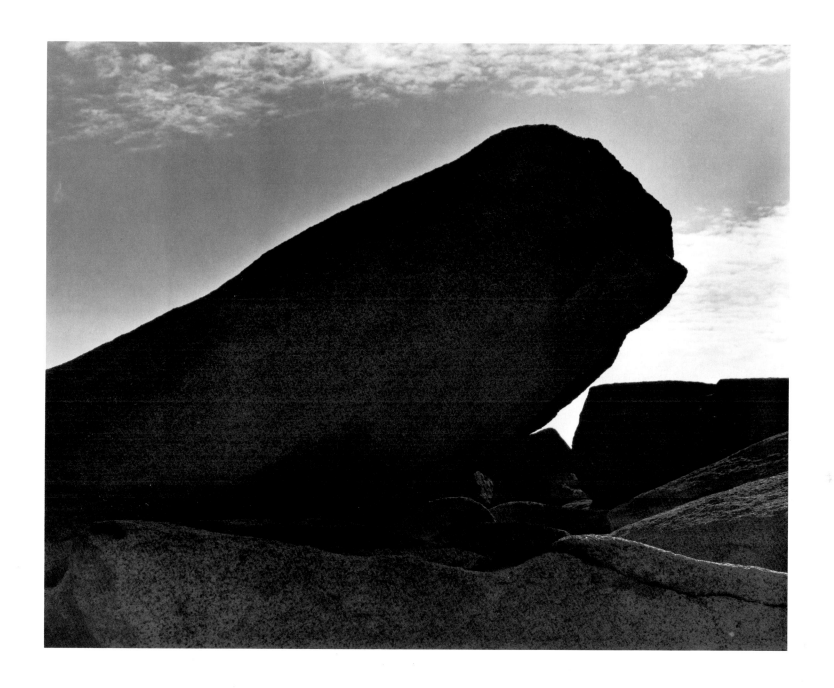

Massachusetts Coast 1974

The dark peak at the far right is a stone in shadow. The darker peak to its left is only the stone's shadow. It appears stronger—more solid—than the stone that cast it. That shadow and the black spearhead shape to the left are the most arresting forms in the photograph.

Negative spaces—areas without substance—that create the illusion of positive forms are intriguing. Visualize a backlit picket fence, black against a bright sky. Are the pickets more substantial than the spaces between them? Try again. Visual juxtapositions controlled by the viewer's mind are so rich in emotional content that philosophies and religions have been based on them. Visual art works characterized as *Yin* and *Yang*, *Tan* and *No Tan*, or positive and negative space, illustrate philosophical theory by optical illusion. Metaphysical considerations aside, photographers respond to the incredible designs, eloquent light, textures, shapes, and mysteries of natural forms and the shape of the space that surrounds them.

This photograph was made with a 210mm lens on Tri-X sheet film through a 25A (dark red) filter. A filter such as a K-2 with a factor of 2 requires two times as much exposure as indicated, or one stop. A filter with a factor of 4 requires two stops extra exposure. The filter factors progress geometrically—2, 4, 8, 16, and so on. Each factor increase requires another extra-stop exposure. The 25A filter, used here, has a factor of 8, so a three-stop increase would be necessary. In this case, however, opening up the aperture three stops would have resulted in insufficient depth of field, so instead the shutter speed was increased eight times, or three "clicks" —from 1/60 sec. at $f/22$, through 1/30 and 1/15 sec., to 1/8 sec. The exposure was made, therefore, at 1/8 sec. and $f/22$.

Since the 25A filter reduces the transmission of the bluer light in the shadows to a greater degree than it does the light from the sunlit surfaces, contrast is increased. The darkest shadow was placed on Zone I and retains a trace of substance in the print. The crack in the rock prints solid black. The lightest sunlit rock fell on Zone V, but was developed to Zone VI—Normal +1. However, the "proper proof" (*Zone VI Workshop*, p. 38) on normal paper showed that the negative still lacked the visualized contrast, so the print was made on Varigam with No. 3 filtration. Since the olive tones of most papers appear more obvious in prints that have large areas of middle gray, the print was toned in selenium; this not only cooled the color but also added an impression of space and strengthened the blacks.

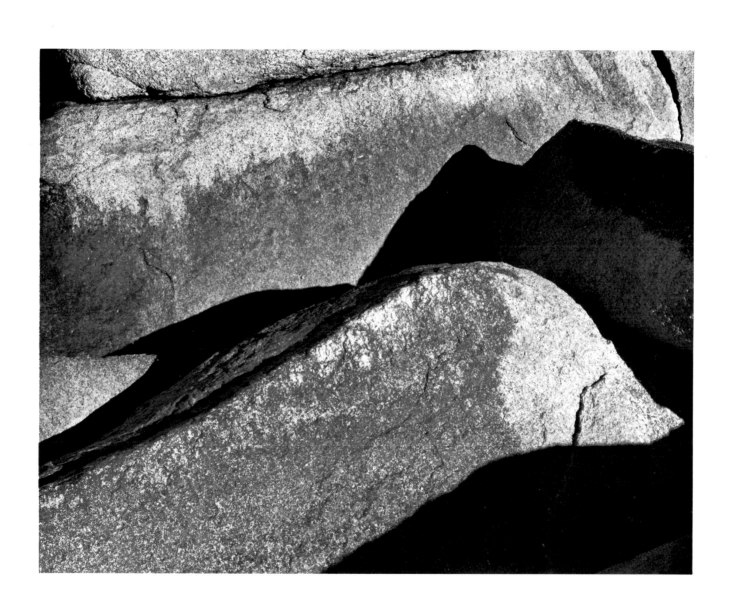

Bass Rocks, Massachusetts 1971

Schoodic, Maine 1972

The similarity of these photographs is principally in the subject matter and the moment of shutter release. In both pictures, the exposures were made at the peak of the wave's explosion when the wave top touched the horizon line.

In the upper photograph, the foreground rocks were brightly lit by the midday sun. This light made it possible to use a fast shutter speed to record the wave and a lens opening small enough to assure sharpness in depth. View camera controls would not be effective in increasing depth of field in this situation; if the lens was tilted forward, or the back tipped to the rear, only the close foreground rock and the horizon would be sharp. The top of the upthrust rock would be out of focus in either case. With the small lens opening and a moderately wide-angle lens, however, it was possible to place the camera quite close to the foreground rock and maintain sufficient depth of field. The proximity of the textured surfaces results in a strong feeling of presence in the print. The viewer is there —really in the photograph.

The lower photograph could not be made in the same way, primarily because the setting sun did not provide enough light for a small lens opening together with the necessary fast shutter speed. To solve the depth-of-field problem, a distant camera position had to be chosen where there was no object close to the front of the camera. This position did not require a small lens stop, but moving back from the subject necessitated a longer lens to eliminate extraneous subject area. Although the long lens has a shorter depth of field, a forward tilt of the lens for sharpness in depth was possible because no surfaces projected out of the same general plane. Because of the remote camera position this photograph lacks the intimate feeling of presence that the other contains. It is more "looked at" than "stood in."

For both photographs about six or eight negatives were exposed to improve the odds of recording the wave's impressive formations. With subject matter of this kind it helps to make a few practice exposures without film to learn the rhythm and timing that should work best. In both instances, it was possible to record the crests as they formed arresting "tension points" with the horizon. During the moment when a moving object starts to change direction, it becomes fixed and a slow shutter speed can render it sharply. A pole vaulter who would be recorded as a blur on his way up or down will appear sharp if photographed during the momentary pause at the top of his leap. In the same way, a wave will "hang" for a moment.

The upper photograph was exposed at $f/32$ and 1/50 sec. with a 121mm lens, which on 4″ x 5″ film covers about the same subject area as a 35mm lens on a 35mm camera. The lower picture was made with a 210mm lens, the aperture at $f/8$, and a 1/50 sec. shutter speed. The 210mm lens covers an image area roughly equivalent to an 80mm lens on a 35mm camera. The upper photograph prints smoothly on No. 2 Varigam, but the lower is contrasty and needs a No. 1 filter. A minus development would have reduced the density of the high values in the lower picture, but this was not possible as the negative was on the borderline of underexposure; a short development would have further weakened the already thin densities of the lower values.

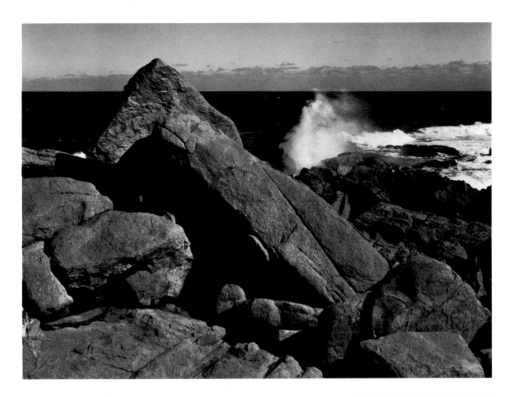

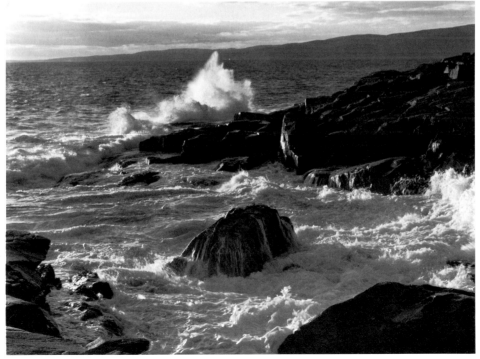

Water Treatment Plant Yonkers, New York, 1970

YAROSCAK AND SHEPPARD, ARCHITECTS

Many industrial installations are more interesting to photograph than residences, office buildings, or schools. Here form really follows function in an honest, uncontrived way. Sorting out the elements and lighting them dramatically in a cluttered space is a difficult challenge; every possible camera position must be carefully examined. As in photographs of natural subjects, the problem is to make order out of chaos.

The impression of depth in this photograph results from several factors: the nearby bolts show threads, the receding valve wheels diminish in size, and distant machinery is seen between the left-hand vertical pipes. Meter readings showed that only one light was needed and it was placed above and to the right of the camera. Although it cast a shadow of the nearest valve wheel, the light showed the foreground details clearly and provided soft highlights on the vertical pipes.

Focusing for sharpness in depth under low-light conditions is difficult. As the lens is stopped down, the image becomes too dim to see. Three methods are available to solve the problem:

1. If a Polaroid back is at hand, a trial exposure will show whether or not the focusing distance was correct. The Polaroid will also supply other useful information concerning lighting, exposure, and composition.

2. If the Polaroid is not available, flashlights or bare electric bulbs can be placed on the nearest and farthest subjects in the picture area and these points of light can then be sharply focused even at the smaller stops.

3. If these aids are not available, depth-of-field charts can be used, assuming a tape measure for measuring focusing distances can be obtained.

Type 52 Polaroid provided a good print when exposed for one minute at $f/64$. Tri-X, though rated the same as Polaroid (ASA 400), is actually one stop slower, and so was exposed for four minutes. The extra two minutes compensated for the reciprocity effect of the longer exposure. The camera was a Sinar 4″ x 5″ with bag bellows and 90mm Super Angulon lens. The light was a 1,000W Colortran combination spot and flood adjusted to the flood position.

Rome 1966

This baroque building is rich in detail and strong in design. The white spheres rest on lines like musical notes. The staircase curves away to the left, disappears, then mysteriously reappears at the right. But to make an interesting picture something more was needed—a point of scale and visual interest. The white painted area of brick at the lower right seemed compositionally ready to frame something. The photograph was finally made when a nun in her black habit was silhouetted against the white rectangle. Her importance to the photograph is obvious if you cover the small section that she occupies.

The compositional "weight" of an object is not related only to its mass, tone, or position. Small areas of high interest or emotional impact can compositionally balance large quiet areas and, in fact, the small areas often require some extraneous space to avoid appearing crowded.

The photograph was made with a 35mm Nikon camera and 50mm lens. The film was Kodak Panatomic-X developed nine minutes in FRX-22. This is a fine combination, yielding sharp, almost grainless negatives of smooth gradation.

Kodak rates the film at ASA 32, but densitometer readings of hundreds of student negatives establishes that proper Zone 1 density (.01 above film base) appears with many meters at an exposure index as high as 64. With Tri-X the opposite is true. Kodak's indicated ASA 400 will only occasionally provide sufficient exposure and most meters must be set at lower indexes. To prove how meaningless the indicated speeds are does not require a laboratory or even a densitometer. Just make a Tri-X exposure (ASA 400) of any subject. Change to Panatomic-X, open 3½ stops (the difference from ASA 400 to ASA 32), and make a Pan-X exposure. If the film-speed ratings were correct, proper proofs would show both negatives matching in tonal value. This however, is not the case. If the Tri-X negative happens to be properly exposed, then the Pan-X negative will be about two stops—four times—overexposed. The conclusion must be that if 32 is right, 400 is wrong, or vice versa, or that both speeds are wrong. Serious photographers test everything and soon realize that what a product does is usually very different from what people say it does.

The print was originally made about 6″ x 8″ on Kodabromide No. 3, but the negative was printed for this book on Ilfabrome No. 2. Although the number designations of these two papers are different, their contrast characteristics are similar. Ilfabrome is a richer paper.

Pemaquid, Maine 1973

Specular reflections are direct reflections of a light source. They are typically seen in the highlights of the eyes in portraiture, and as reflections from shiny metal surfaces, mirrors, wet surfaces, and water itself. The angle of the lens axis relative to the light source determines the presence and position of the reflections. The shape of the light source and the texture of the reflecting surface determine the character of the highlights.

On a textured horizontal surface as shown here, specular highlights can only be seen if the light source is behind the subject (backlighting). The ripples in the water form tiny flashing mirrors that directly reflect the sun to the lens. To retain the crystalline scintillations, the fastest available shutter speed should be used. There is no need to be concerned about underexposure of the reflections because they are so brilliant that they will print pure white regardless of the exposure used. When making meter readings, these highlights should be ignored—indeed, the new battery meters, if exposed to this intensity of light, will give distorted readings for an hour.

Backlit photographs taken across a perfectly still lake at sundown often show the sun's path as a featureless three-inch strip of chalky white. Rippled water is more interesting.

More creative photographs of sun on water are usually made when the water is disturbed by individual sparkling highlights. Since backlight is an ingredient of these pictures, the probability of flare on the negative is great. The lens "sees" a circular image. The rectangular negative is within this image circle, but the projected image outside the four sides of the negative area bounces about in the camera and fogs the image. This additional fogging exposure degrades the crispness necessary in pictures of this type. More obvious indications of flare might include a dense area along one or more edges of the negative or octagonal shapes of higher density superimposed directly on the image.

The best possibility of preventing flare under these circumstances is through the use of a modified lens shade. The circular lens shades supplied by manufacturers are poorly designed. To be effective, shades should be rectangular and in proportion to the negative to cut off light outside the image area. Looking through the camera's viewfinder, one can apply four strips of black tape across the front of the round lens shade to form a rectangle slightly greater than the area seen through the viewfinder. The tape improves the efficiency of round lens shades in any situation and is particularly necessary in backlight situations. The Hasselblad bellows lens shade and similar view camera lens shades are efficient, as they can be adjusted for sharp cut-off just outside the field of individual lenses.

Surging water makes visualized compositions of the scintillating areas difficult, so it is a great advantage to have a choice of negatives. Several negatives were exposed at 1/400 sec. at $f/16$, which was the exposure indicated for a Zone V placement of the smooth water. The 1/400 sec. shutter speed (actually 1/380 sec. for this shutter) was used to record the sparkling areas crisply. The great depth of field, even with the large lens opening necessitated by the fast shutter, was easy to obtain by tipping the lens forward.

The 4" x 5" Tri-X negatives show no flare, a result of the good coating of the 210mm Symmar lens and the Toyo bellows lens shade. The negatives were developed normally and the best composition was chosen for printing. When the first print was made on No. 2 Varigam, the lower values in the stone and seaweed appeared too dark when the water and reflections appeared as visualized. A No. 1 filter was substituted to reduce the contrast and the resulting print is reproduced here.

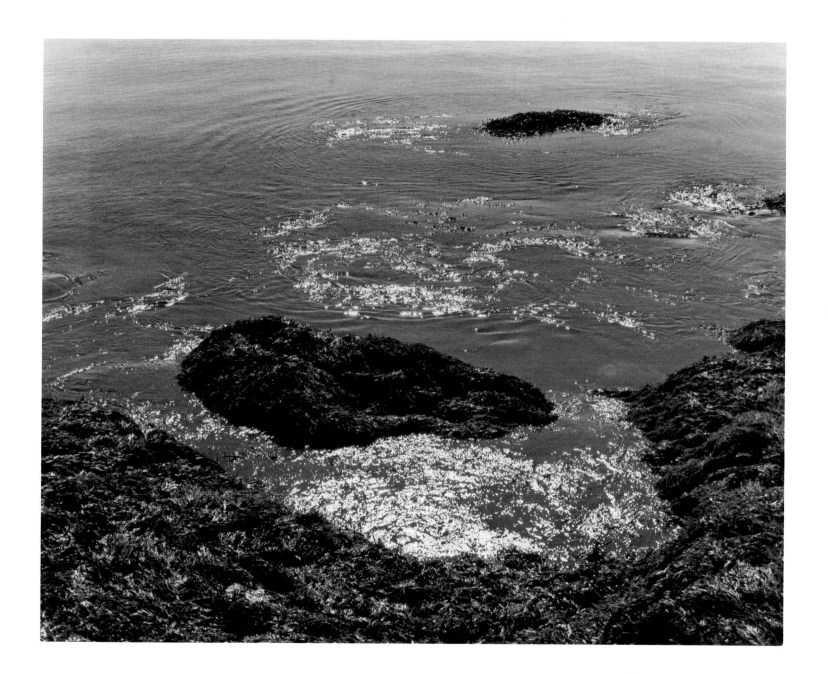

New Hampshire 1969

Flowing water over dark rock produces darting reflections. These flashes of light are so rapid that the fastest available shutter speed records them as streaks.

In the picture shown here, the mass at the lower right is rock above the stream's surface. It was placed on Zone II and therefore appears in the print as a substantial, but textureless, form. The desired placement of the dark water was Zone I; the highlights, however, would inevitably print as pure white. The exposure dictated by the Zone II placement of the rock was 1/250 sec. at $f/8$.

The limited depth of field provided by the $f/8$ aperture was not a problem even at the three-foot distance. The camera was first pointed down to cover the desired area with all controls at neutral positions. After "focusing on the far" with the lens wide open at $f/5.6$, the lens was tilted forward as the camera was refocused, until the near foreground reflections were also sharp. Then the lens was stopped down to $f/8$ and the exposure was made.

The Tri-X negative was developed normally in HC-110 and the print was made by choosing the test strip exposure that showed the foreground rock as a Zone II print value and the dark water as a Zone I. The reflections are so dense on the negative that they print pure white even at a test-strip exposure three times as long as the printing exposure chosen. A 6″ x 8″ print was made on Varigam. The small print size was chosen because it suited the delicate subject best.

Baccarat Crystal 1969

Many young photographers feel hampered in their commercial work because they lack the funds for the extensive equipment owned by the major studios. It is refreshing (or perhaps discouraging) to remember that Edward Weston owned only a battered 8″ x 10″ camera and a 4″ x 5″ camera. His "studio" for the marvelous photographs of the peppers was his front porch. His "set" was an old tin funnel. The film was so slow that at $f/128$ his exposure lasted over three hours! He had no lights and needed none.

Sometimes a homemade setup can be as effective as a fancy studio set. An artificial light was used for this picture—a mushroom-shaped 150W flood bulb on an extension cord with a cardboard "barn door" arranged to cast a shadow on the foreground. The background was a four-foot sheet of white paper taped to a wall and curved forward across a table.

Glassware edges will show a black line or a white line depending on whether they reflect a dark or light value. In this case, the bowls and rims of the glasses reflect the dark area shadowed by the "barn door." The dark edges stand out clearly against the white background. The smallest glass farthest from the lens and the lighter "horizon" give an impression of receding space. Since glassware is ordinarily viewed from slightly above as it rests on a dining table, if a sense of reality is to be achieved in a photograph, the height of the lens should be at normal eye level.

A trial exposure was made on Polaroid film. Polaroid is of great help in delicate lighting situations where a fractional movement of camera, object, or light source can make or break the picture. The desired lighting may be difficult to see on the ground glass, but it is apparent in the Polaroid print. A special Polaroid back was used on the view camera.

When the trial exposure proved satisfactory, 4″ x 5″ Versapan film was exposed one minute at $f/64$ through a 12″ Goerz Artar lens. A fairly distant camera position and a long lens is required to avoid shape distortion of circular objects. The film was developed Normal +1 in FG-7. The indicated exposure, placing the glass bowls on Zone VI, was 10 seconds at $f/64$, but the bellows extension to 18″ required twice the indicated exposure, or 20 seconds.

Reciprocity effect requires increased exposure time for exposures longer than one second; the effect is in fact often twice as extreme as film manufacturers indicate. In this instance, the indicated exposure with bellows extension was 20 seconds, and the manufacturer recommended an exposure of 40 seconds to compensate for reciprocity. In my experience, if you expose two minutes rather than 40 seconds the chances for success are better. Because reciprocity effects are greater than manufacturers indicate, and because meters are not often linear and indicate more light than exists at low levels, it is rare to see an overexposed negative made in dim light.

Hartsdale, New York 1971

There must be millions of fascinating, unexplored photographic situations depicting movement. Photographs of this type cannot be precisely visualized and only an ample supply of film will reduce the odds against failure. The element of taste enters. At what point is the subject dramatized fully? How far can the photographer modify or impose before the photograph becomes a technical exercise?

The photograph shown opposite was made in the somber light of a gray day. The cherry tree was protected from birds by the sheer netting, one edge of which slowly rose and fell with each gust of wind. My first exposure proved to be a failure. It was a five-second exposure made possible by a neutral density filter to hold back the light. A messy looking negative resulted that contained no sense of the floating, ghost-like netting.

The second experiment was more interesting. The exposure decided upon—$f/22$, 1/4 sec.—was divided in two. Two exposures were made at $f/22$ and 1/8 sec. The first exposure was made when the netting was lying still on the ground; the second, when the netting rose to the corner of the distant window, which was used for a reference point. At the same lens setting a third exposure was added when the material floated past the window corner. This apparent overexposure was inconsequential. Theoretically, the extra exposure amounts to a half-stop, but there is an intermittency effect that comes into play in multiple exposures. For example, a one-second exposure will produce more density than four $\frac{1}{4}$-second exposures. The netting appears heavier in the position of repose because in that area it received three overlapping exposures. It is more delicate in the next movement to the right where it was recorded twice and finally very wispy in the last segment, which received but one exposure.

The 10″ x 13″ print was made on Varigam paper. Because of the very flat light, the +1 negative development was not sufficient in itself to provide the needed contrast, so a No. 3 filter was used. The lawn areas were burned in darker to accentuate the whiteness of the billowing cloth. Long toning in very dilute selenium added a cold blue-black that recreated the chilly spirit of the moment.

Millerton, New York 1970

To the naked eye, sunlight filtering through the trees is lovely and soft. To the camera, the sun reflecting from the leaves is as bright as though the light were coming from as many mirrors. This problem of extreme contrast can be approached in several ways. My experience shows that shortening the exposure to record the highlights with acceptable tonality is not the answer as it plunges the shaded areas into dense gloom. Overexposure and underdevelopment seem to be indicated in situations like this, but because of the inevitable compaction of the lower values, the luminosity of the light—the actual subject of these photographs—is lost. Use of a blue filter to lighten the shadows is often recommended, but I find the result tonally unacceptable.

Despite years of disappointments I persisted in attempting to recreate the atmosphere of sunlit woods. Success came one day when I was waiting for clouds to pass by. Suddenly the solution became obvious. For years I had made commercial photographs of buildings by exposing for the face of the building at dusk, then exposing again for the lighted windows at night. The problem in the woods was identical and the technique employed ought to be the same: double exposure.

I made the first exposure as a cloud passed over the sun. The leafy areas were placed on Zone IV. When the sun dapples reappeared, I made a meter reading of a nearby sunlit leaf and made a second exposure with that value placed on Zone VII. The second exposure, to add the sunlit areas, was so short that the effect on the first exposure was negligible. Since there was no wind at all, each leaf remained in perfect register. The first exposure was for $\frac{1}{2}$ sec. at $f/32$, the second exposure was for $1/60$ sec. at $f/32$, both with the 121mm (5″) lens.

4″ x 5″ Tri-X developed normally in HC-110 provided a negative that printed easily on No. 2 Varigam. The print developer used was Ardol 1:1. This developer is less brilliant than Dektol but is very gentle to the lower values. Dektol has a tendency to push the delicate lower tones into black and must be handled more carefully than Ardol if luminous low values are desired. Ardol also imparts a warm tone, which seemed appropriate for this scene.

Clarkson College Potsdam, New York, 1970

THE PERKINS AND WILL PARTNERSHIP, ARCHITECTS

This photograph further illustrates the technique used for the previous photograph.

The first exposure was made toward dusk when the sky and building showed a two-Zone difference. The building was placed between Zones III and IV, and the sky fell between Zones V and VI. The exposure was for one second at $f/32$, with Tri-X sheet film.

A subsequent exposure was made about two hours later. By then the superintendent had turned on the fluorescent fixtures and one of the lights was metered close up. Its value was placed just below Zone VIII and the indicated exposure of 1/5 sec. at $f/32$ was added to the original exposure. By that time, the sky and building were dark so the second short exposure was affected only by the lighted windows; and the windows are not blocked up by overexposure as would be the case if the photograph was attempted with a single exposure.

When photographing outdoor spaces seen from inside through glass walls or windows, the procedure can be reversed. The first exposure is made in daylight with the average of outdoor values on about Zone VI to VII. The second exposure is made at night with the interior lighted by floods or flash. The average interior values are placed one to two Zones lower than for the first exposure. As with the photograph of the building, the artificially achieved result is emotionally realistic.

Water Treatment Plant New York

YAROSCAK AND SHEPPARD, ARCHITECTS

Water treatment processing includes an agitation stage. While the water is in the large tanks shown here it is continuously blended by large open weave mats mechanically raised and lowered. To show this repeated movement, a double exposure was made.

The first exposure was 3/4 of the total determined exposure. It was made when the mechanical arms reached their highest position. The subsequent exposure was made when the arms were at their lowest position. If the two exposures had been equal, the impression of movement would have been missing—the single set of arms would have appeared as solid scissor-like crosses. With the second shorter exposure, movement is indicated by a "ghost" image that shows a lack of substance.

The total exposure required to place the sides of the concrete beams on Zone IV and the tops on Zone VI would have been 1/50 sec. at $f/22$. The first exposure, then, was 1/50 sec. about 1/3 stop between $f/22$ and $f/32$, and the second exposure was 1/200 sec. at $f/22$. The Tri-X sheet film was developed normally and the negative printed easily on Varigam with the No. 3 filter.

Note: Double exposures require a rigid tripod if the two exposures of the stationary parts of the image are to remain in perfect register.

Sherman, Connecticut 1971

Interaction between contradictory subject elements is the theme of many photographs. The photographs of Diane Arbus, for example, concentrate on human interaction: Two people, obviously bored and unhappy, lounge beside a swimming pool in a shocking refutation of the joys of suburban affluence; and, in another photograph, an eight-foot giant is contrasted disturbingly with his normal sized parents. Henri Cartier-Bresson's gripping photographs, to cite another example, are also rich with interacting contradictory elements: A group of boys laugh and play in the rubble of a bombed-out building; one of the boys is an amputee.

When conflicts occur within images, the opposing elements are dramatized: Small becomes smaller because of the large, rough becomes rougher because of the smooth, white becomes brighter because of the black. This picture contains black against white, hard against soft, wet against dry, movement against solidity. In particular, the foreground rock in sharp focus contrasts tonally and emotionally with the soft spray of the rapids. The interaction between these elements adds to the impact of both.

The photograph was made with a twin-lens Rolleiflex and a Planar $f/2.8$ lens. The Panatomic-X film was exposed three seconds at $f/22$ in the dim light, and developed eight minutes in Rodinal diluted 1:50 with one five-second agitation cycle (two tip-overs) every 30 seconds. An 8″ x 10″ print was made on Varigam with No. 2½ filtration; the background stones were darkened by 50% additional exposure to accentuate the whiteness of the water.

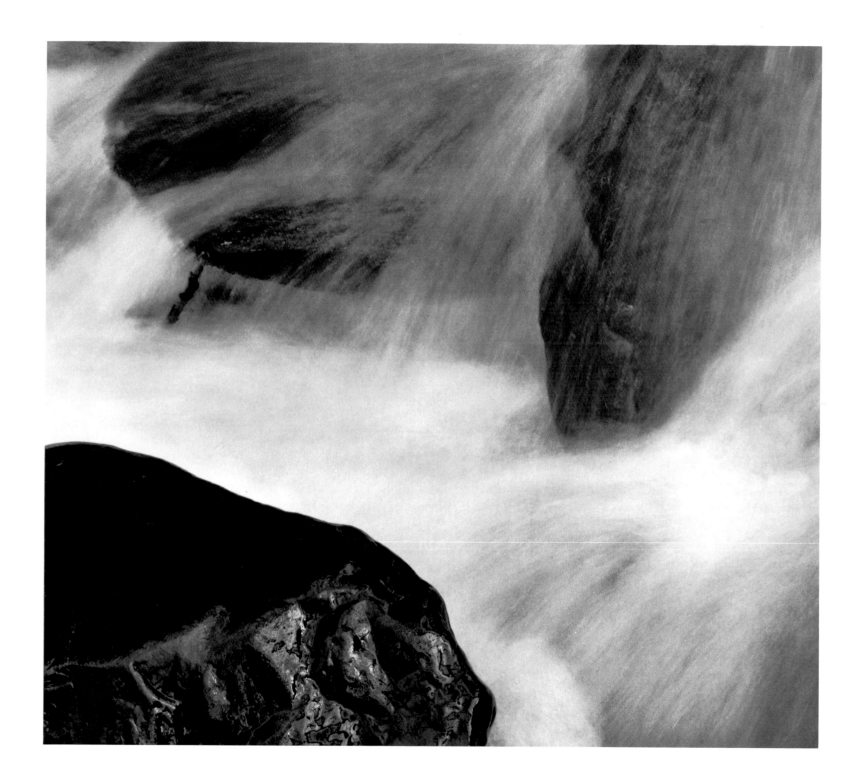

Near Lyme, New Hampshire 1973

Random movements of natural substances are fascinating. Snow driving in gusty winds, surf exploding against rock, bubbles, rapids, waterfalls, and changing patterns of clouds all provide rich material for the photographer.

This photograph of smooth water sliding downstream over a small ledge required a 12-second exposure. The appearance of the water was black, changing to polished pewter where the curved surfaces reflected the fading sky light. The picture was made so late in the day that a lighted match had to be placed on the rock to furnish a focusing point. The dark serpentine form on the rock is dampness from a small trickle of water. (Wet rock is darker than dry rock except when sunlight makes wet areas reflective.)

The tripod was set up almost directly over the subject. To accurately judge an exposure for small inaccessible areas, a spot meter is required. The S.E.I. photometer, with its $\frac{1}{2}°$ spot and fine accuracy in low light conditions, was helpful in this situation. The dark water was placed on Zone II to retain an impression of substance; the high value fell on Zone VII. The exposure indicated was 3 seconds at $f/22$, to which the bellows extension factor (two times for a 12″ lens extended to 18″) had to be added. This total (six seconds) was then doubled to compensate for the reciprocity departure inherent in all films.

The camera was a 4″ x 5″ Sinar; the film was Tri-X developed normally in HC-110 dilution B and printed size 7″ x 9″ on No. 2 Varigam. The print was brought into tonal balance by additional enlarging exposure to the upper left corner.

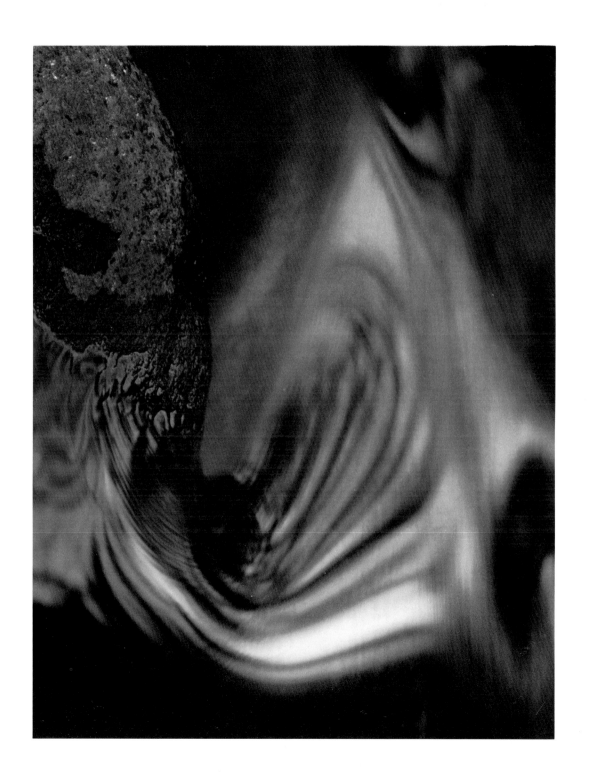

Schoodic, Maine 1972

The area covered in this photograph is about four square feet. Cover the upper 2/3 of the photograph with your hand and you see an island viewed from a plane. Cover the lower part and a rock face the size of Mount Rushmore appears. The only indications of scale are the pebbles scattered along the water line.

There are also no indications that the pool is level or that the rock face is vertical. This lack of orientation adds a note of unreality to the photograph. The puzzle would be quickly solved by the addition of a strong indicator: For instance, a child's sailboat in the pool would show that the foreground substance is water and therefore horizontal; its shadow would bend where it joined the juncture of pool and rock to show that the walls are vertical; and the known size of the toy would reduce all of the elements to their actual dimensions. All abstract qualities would be factually described. In this case, however, such a literal explanation of the physical facts would diminish the emotional content.

The photograph was made in near axis light on 4″ x 5″ Tri-X film with a No. 12 medium yellow filter and a 210mm lens. The filter darkened the water and the few small shadows. The water was placed on Zone IV, but the filter reduced it to about Zone III. The dark rock fell on Zone V, the light rock on VI. The indicated exposure was 1/30 sec. at f/22, but the exposure used was 1/15 sec. at f/22 to compensate for the filter. The negative was developed Normal +1 to increase the separation between the salt patterns on the wall and the stone. Normal +1 development is usually indicated when the subject of the photographs is entirely in sun (no shadows) or entirely in shade. There is a great difference in the amount of reflected light between these two circumstances, but the actual contrast range is short in both cases and is often less than would be emotionally realistic.

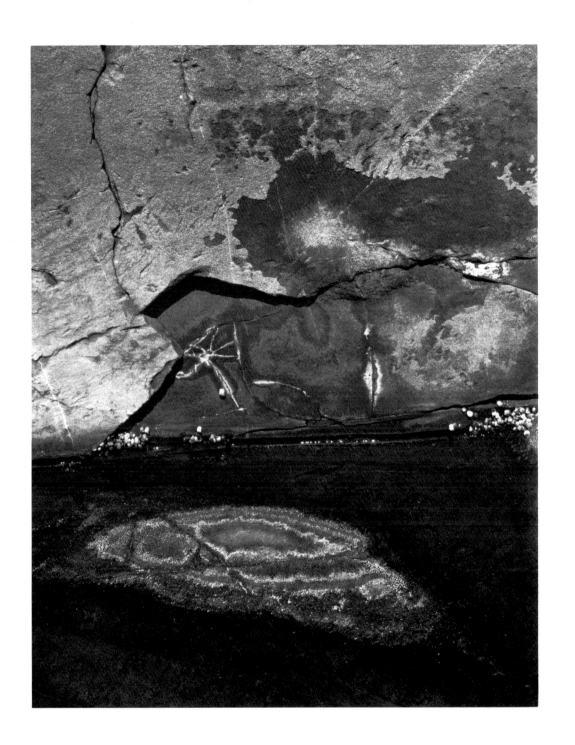

Lone Pine, California 1969

There are no nearby indicators of scale in this photograph, yet there is no difficulty in understanding the dimension of the subject. Its size is known from the viewer's past experience.

Although no object is close to the camera, depth and space are strongly implied by the four progressively lighter tones. The completely shadowed foreground (Zone IV) gives way to broken sunlight on the lower slopes (Zone V), full sun on the highest peak (Zone VII), and finally a snowstorm on the most distant peak at the left (Zone VIII). It is understood that the area is huge since four conditions of light and weather are simultaneously visible. If the photograph had been made when all areas received even light, the tonal steps signifying distance would be absent and there would be an impression of flatness—as with a tapestry.

The highest possible placement was desired to insure that the large, important foreground area would contain maximum detail. To accomplish maximum printable negative density, the storm area, the highest value requiring tone, was placed on Zone VIII. The storm area was measured with 1° spot meter. This high placement permitted the foreground to fall on Zone IV.

With a No. 12 filter to reduce haze and increase the separation between the clouds and sky, the exposure on GAF Versapan 4″ x 5″ film was 1/10 sec. at $f/22$. The film was developed normally in FG-7. The camera was a Graphic View, since replaced by the more versatile Sinar. The lens was a 210mm Symmar.

The vast area appears dramatic in a 14″ x 20″ print. The top of the print was cropped two inches to bring the peak close to the top edge; this "crowding" of huge forms strengthens the impression of their mass.

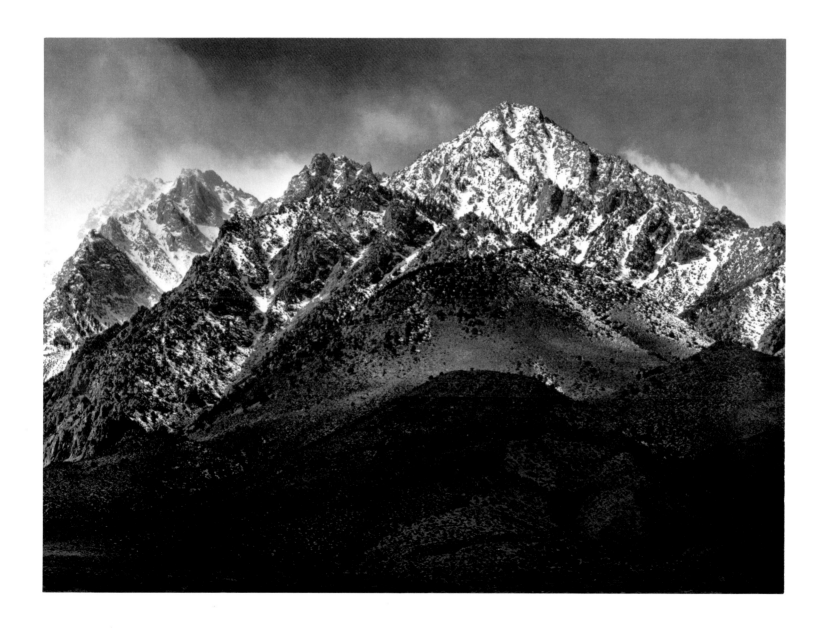

Pine Plains, New York 1971

Ephemeral shapes and moods of nature have always inspired photographers. Though Strand, Stieglitz, Adams, Caponigro, Gagliani, Bullock, Edward and Brett Weston, and many others are capable of superb work outside this domain, their intimacy and interaction with source material have provided some of the most stirring photographs in the history of the medium. Delicate forms in nature contain a full measure of their own magic; a sensitive photographer approaches these forms quietly and photographs them with respect.

The photograph was made with a Sinar 4" x 5" camera and Goerz Artar 12" (300mm) lens. The bellows was extended to 18", requiring twice the exposure needed for normal (12") bellows extension. The darkest water was placed on Zone II, the large ice area fell on Zone VI, but the Normal +1 development increased the highest value to Zone VII. The tiny specular highlights in the clear ice print pure white—Zone IX or higher.

The indicated exposure was 1/10 sec. at $f/22$, but in very cold weather shutters may be slow and meters may be sluggish. Either problem will result in overexposure, so several exposures progressively shorter than the one indicated were made. The negative finally selected was exposed at 1/25 sec. at $f/22$.

A 6" x 8" print was made on Varigam No. 2½. Icy blue-black appeared after about 15 minutes of toning in selenium, diluted two ounces to one gallon of water. The print color enhances the cold brilliance of the scene.

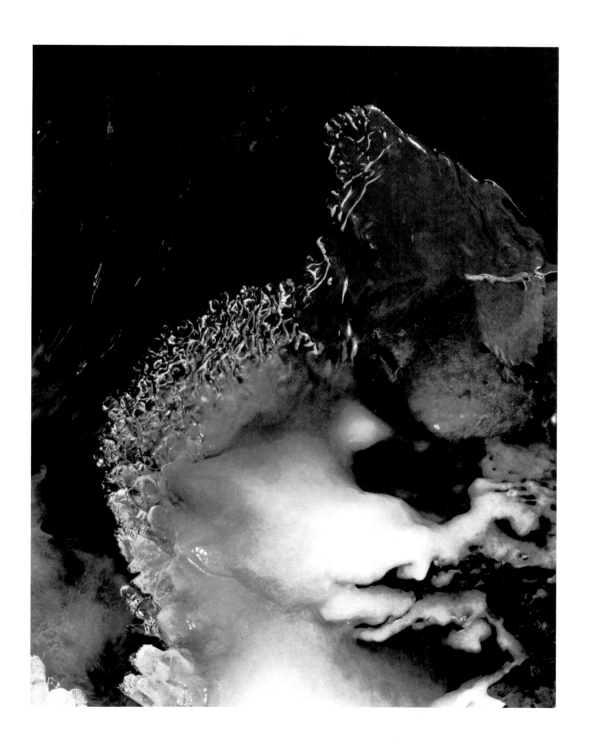

Baker River Warren, New Hampshire, 1970

The photographer Paul Caponigro, looking at the first version of this print said, "The water isn't wet—reprint it and make it wet." How? More contrast? Less? Different paper? Different developer? What imaginative, simple, virtuoso trick would allow the viewer to experience the clarity of a spring-fed mountain pool? Paul's response to my questions was disappointingly ambiguous. "The way to do it," he said, "is to do it. Go into the darkroom and don't come out until the water is wet."

Four hours, thirty sheets of paper, various developers, additives, exposure times, development times, and toners were expended on the tiny pool until, finally, the water was wet. A year later in Paul's darkroom I watched him spend two days creating a pilot print for his "Portfolio II." The print he got after fifteen minutes would have excited most photographers, but he insisted on a print that "lived." He got it using the very same "trick" he had taught me. Persistence.

This negative was made on 4″ x 5″ Tri-X film developed Normal +1. Although the area photographed was small, a wide-angle 121mm lens was needed to assure sufficient depth of field. The reflecting surface was only three feet from the lens, but the trees reflected from it were about fifteen feet above the pool, requiring sharp focus from three to about eighteen feet (lens to pool to tree totals eighteen feet). Focused at 5 feet, this lens is sharp from 2 feet 10 inches to 21 feet at $f/32$. Using $f/45$ provided a margin for focusing error, and the exposure was for one second. The day was gray and the plus development helped to separate the close tonalities within the stone, which was placed on Zones V and VI. The only pure white appears in the thin line where the water meets the rock in the lower right corner and the only black is seen in the narrow band of wet rock just above it.

The print was made on Ilfabrome No. 2 paper developed six minutes in Ardol developer diluted 1:3. One ounce of 10% glycin solution was added per quart of developer; the glycin cooled the brownish tones of the paper-developer combination. Long toning in very dilute selenium brought the tone still closer to the desired neutral gray.

Point Lobos, California 1969

For quite some time a little girl had been wandering about the pebbled beach near where I was working. Suddenly she stooped and picked up one of the thousands of stones. "Why did you pick up that one?" I asked. She gave me the incredulous look that children reserve for grown-up fools and replied impatiently, "Because it wanted me to." She was drawn by that particular stone for no rational reason. In the same way, when the photographer is mysteriously drawn by the subject, the picture often has a special power of purity.

This photograph was made with the high noon sun behind and slightly to the left of the camera. This near axis light produces an interesting effect at the upper edge of each stone and pebble. There is a tiny black line—the shadow of the stone—and this "limb effect" clearly delineates each pebble.

The brilliance of the subject suggested a high placement. The large stones were placed between Zone VI and VII, then developed Normal +1. Some of the pebbles print pure white, some pure black, but the overall effect of the pebbled area is a muted gray. The view camera was pointed down at a 45°

angle and the 210mm Symmar lens was tilted forward to attain simultaneous sharp focus for the foreground and background. An orange "G" filter was used to darken the tiny shadows. The exposure factor for this filter seems to be 4 in clear blue light, requiring that the lens be opened two stops or the shutter speed be reduced to ¼ the indicated time. The exposure indicated was 1/25 sec. at $f/45$, but to compensate for the filter an exposure of 1/25 sec. at $f/22$ was made.

The print was made originally on Kodabromide No. 3 and later reprinted with better result on Ilfabrome No. 2 developed four minutes in Dektol 1:2. Ilfabrome's greater brilliance and dimensional quality produced a finer effect. Three ounces of 10% solution of sodium carbonate was added to three quarts of Dektol developer to strengthen the tiny black areas. High contrast paper would have also strengthened the blacks, but the large stones would have lost their smooth tonality. Prints of several sizes were made, but the 6″ x 8″ size seemed most appropriate.

84

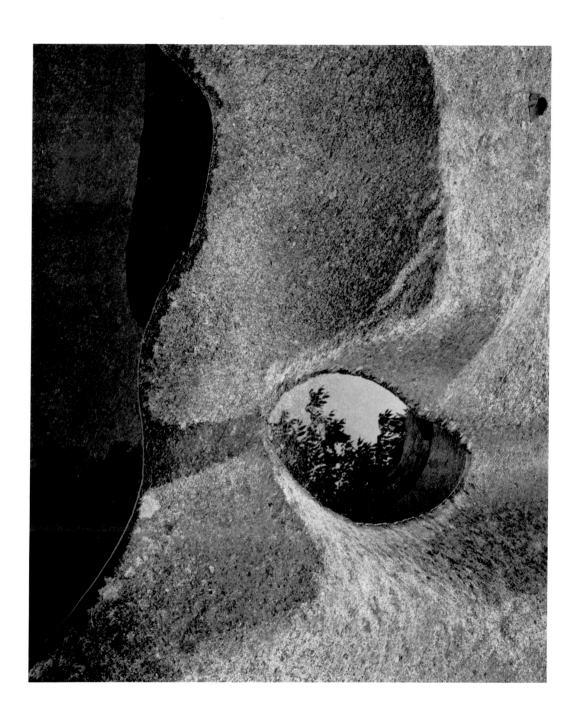

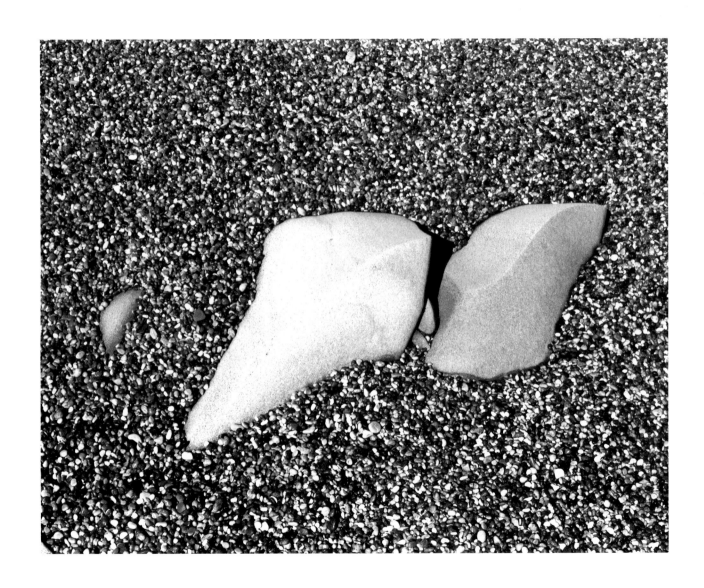

Near Gouldsboro, Maine 1972

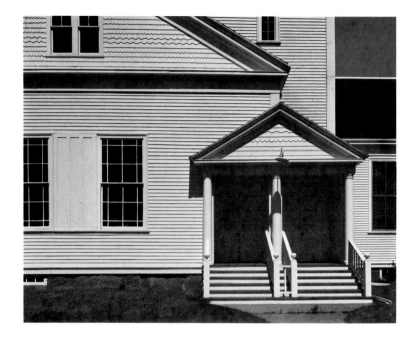

Although taken from the same camera position, these photographs display a startling difference in the apparent depth of the scene photographed. In the upper exposure the Zone V gray in the upper right-hand corner appears to be part of the building. The cloud filling that space in the second picture proves that the gray square is actually sky. The distant cloud in the second photograph conveys a completely different impression of depth.

The left to right positioning of the camera aligned the roof peak of the entrance portico with the corner of the structure to its left. A closer relationship between the peak and the pointed shadow above it could have been achieved by moving the camera forward. That closer position, however, would have caused the upper slanted roof line to cut across the corner of the narrow window. In addition, the closer position would have destroyed the relationship between the right-hand corner of the portico and the top corner of the window.

The entrance handrails are the highest value in the print, not because they are whiter, but because their reflective angle throws the noon light directly back toward the lens. The handrails were placed on Zone IX—pure white in the print. The clapboard in sun fell on Zone VIII, the shaded entry doors and the sky on Zone V, the shadows under the eaves on Zone IV. The eave shadows would be expected to reflect as much light as the shaded entry doors, but in this case they do not because the stoop is reflecting direct sunlight up against the doors. The roof fell on Zone III and pure black appears only in the windows. The camera was the 4″ x 5″ Sinar with 210mm lens mounted on a modified Majestic Tripod. The exposure was 1/25 sec. at f/32 with a K-1 filter, which has a 1.5 factor (½ stop). The Tri-X film was developed normally.

The prints were made on Varigam without a filter and received no manipulation during exposure. A short (1½ minute) print development in Dektol 1:2 gave these prints more brilliance than shorter exposure and the more usual two-minute development would have provided.

Which photograph do you prefer?

Connecticut Residence 1971

MARCEL BREUER AND HERBERT BECKHARD, ARCHITECTS

Breuer structures are characterized by a purity of line with which no decorative clutter is permitted to interfere. The often-used themes of these famous designers include broken joint quarry tile flooring, cedar walls, large glass areas, and uniquely designed exterior decks. These decks avoid the appearance of appendages, as the main roof continues around their perimeter. The striking spaces that result are like outdoor rooms with skylights. No safety railings interrupt their open flow; a single thin stainless steel cable and four-inch-high "kick board" provide adequate protection.

In order to photograph architecture effectively, a photographer must understand all of the features, physical or otherwise, that the designer wishes to emphasize or, in some instances, to minimize. Conferring with the designer, finding out what his feelings are, what he is proud of, what features didn't work out too well, and how the pictures will be used puts the photographer in the best position to satisfy the client.

This photograph was made, advantageously, on a rainy day. The wet deck adds sparkle, the outdoor light is pleasantly subdued, so minimum interior lighting was required to provide a pleasant balance. One floodlight was aimed from right to left to illuminate the decoy and wall. When the average of the exterior was placed on Zone VI, the interior wall fell on Zone II; it would have been nearly black in the print. The floodlight position was adjusted until the wall reflectance was raised to Zone IV.

A 90mm wide-angle lens was used. The 4″ x 5″ camera had to be somewhat lower than the usual eye-level to show the skylight configuration over the deck. The negative was developed for Normal and prints well on No. 2 Varigam with no manipulation.

U. S. Plywood Co. Brewster, New York, 1969

The requirements of commercial architectural photography often exhaust the photographer's visual and technical resources. Photographs must not only be dramatic to satisfy the client and attract the attention of the magazine art directors, they must also clearly explain the construction of the building in terms of shape, materials, and use.

These requirements are often in conflict, and in some instances there is no way that photographs can fulfill any of the client's wishes. Visualize a ten-story brick building on the south side of a narrow city street. No ray of sunlight ever brushes its north-facing facade and tonally the brick can only be reproduced in a photographic print as a muddy, textureless gray. Directly in front of the building are a fire hydrant, two telephone poles with sagging black wires, and several "No Parking" signs. In addition, cars are parked there, obscuring the entrance and part of the first floor. The street is so narrow that the widest lens covers only a third of the building, so an oblique camera position must be chosen to include the full height of the structure. In the ground glass, the building appears as a sliver up the center of the format behind a double row of parked cars and trucks. Impossible.

Fortunately, this assignment presented no difficult problems. Although the ground in front of the building slopes down so sharply that a frontal camera position could not be used, this was no obstacle since a frontal position would have made the one-story structure appear to rear unnaturally high. In addition, the angular projections, which are a main feature of this structure, would read as flat shapes with a saw-toothed roof line.

To introduce some tonal variety into the repetitive outjutting corners of the office cubicles, the vertical slat shades were adjusted to various reflective angles. A dramatic sky was manufactured by use of an E-23 (orange-red) filter. The photograph was made when the pointed shadows on the white base assumed attractive shapes that indicated the angular wall projections.

The 121mm (5") lens was sufficiently wide to cover the necessary area. The 4" x 5" camera back was swung away from the building to increase the convergence of the horizontal lines, thereby "stretching" the building to a more imposing length. Tri-X film was exposed for $1/8$ sec. at $f/32$. (The indicated exposure was $1/30$ sec. at $f/32$, but the filter dictated the longer exposure.) The important high value—the white plaster foundation—was placed on Zone VIII to show a trace of tonality. The reflective metal flashing at the roof edge printed pure white and the windows fell on Zones VIII, VII, VI, V, and IV. Pure black is required if a print is to attain maximum brilliance and it appears here in the small wedges of dark roof first showing above the fourth cubicle.

The rather severe abstract design is more striking when displayed large, so a 14" x 20" display print was made and mounted on a 20" x 26" board.

California 1969

A weather front known as a "Sierra Wave" is formed when air masses of different temperature meet over the mountains. It is said that the updraft created can carry oxygen-equipped gliders to a height of 30,000 feet or more. Photographing these spectacular events requires good luck, since they appear quite rarely and disappear quickly.

I first saw this wave form from the car while driving through a seemingly endless housing subdivision. A photograph of the sky without the horizon could have been made, but without a base all sense of scale and vast space would have been lost. I turned the car around and drove quite recklessly toward the subject until finally a clean foreground was reached. The 4″ x 5″ camera was quickly set up with a 90mm Super Angulon lens and G filter.

No time was taken for meter readings as the shape was beginning to fade. Experience gained through many exposure readings has shown that in any sort of fairly normal light conditions, when "realistic" negatives are the goal, a Tri-X overexposure of even the brightest subjects is impossible if the lens is set at 1/125 sec., $f/45$. With the orange G filter, that exposure would be modified to 1/125 sec., $f/22$.

The first exposure was made, therefore, at 1/30 sec. and $f/45$, guaranteeing underexposure. This was quickly followed by four more negatives, each exposed one stop more than the last. The last negative was exposed ½ sec. at $f/45$, a sure overexposure. Bracketed exposures, to be effective, must include a known underexposure and a certain overexposure. This approach, though not in the best tradition of precise photography will guarantee a usable negative in situations where seconds count. The five negatives were all developed Normal +1 and the "Proper Proof" clearly indicated the superiority of the exposure made at ¼ sec. and $f/45$.

To brighten the curved wave form, the print was made on Varigam with No. 3 filtration and developed two minutes in Dektol diluted 1:2. The sky at the right of the white curve printed lighter than the sky to the left, as the sun was at the right. Since the sun itself is not in the photograph, this light sky area appeared unnatural. When the print was made, therefore, exposure was added to the right of the wave while the rest of the paper was shielded with a cardboard bent into a curve corresponding to the wave shape.

Near Bridgeport, California 1969

The ominous gray-white light that precedes a snow storm made it almost impossible to see the shape of the hills against the leaden sky. So slight was the tonal variation between snow and sky that several procedures were required to insure sufficient separation. The negative was exposed through the most extreme filter available, a dark red 25A filter requiring a factor of eight, or opening up the lens three stops. This filtration with plus development provided a delicate but adequate tonal separation. The snow was placed on Zone VIII and though the sky indicated the same brightness on the meter, the filtration reduced it to VII. The near trees fell on Zone V, but appear darker in the print because of their relationship to the pure white background.

In order to show the distant pines black, the contrast had to be expanded in printing, so a No. 3 filter was used with Varigam. The straight print shows a weakening of values at the right and left edges, so edge burning of about 10% extra exposure was added to balance the values. The print has a surreal, flat, airless look, and the only indication of depth is the progressively diminishing size of the distant trees.

Effective sizing of prints is an aspect of creative photography that has had less attention than it deserves. There is a significant difference in the emotional response generated from different-sized prints made from the same negative. It is dangerous to generalize, but a few thoughts might be considered:

Big landscapes may work well in 11″ x 14″ or larger prints. However, if the subjects in the landscape are delicate and well defined, as in this and the photograph of the Gaspé Village on page 41, a small print about 5″ x 7″ will often add to the effect. Portrait heads larger than 8″ x 10″ are often distracting, while contact prints from 4″ x 5″ portrait negatives often embody great power and beauty. My preference for prints of moderate size is also influenced by physical considerations as well. For example, unless a print is exhibited at a distance, viewers will approach and view a print from reading distance; and if the print is large, the eye must wander over it and the print will be seen as a group of parts rather than as a unified whole.

Edward Weston's 8″ x 10″ negatives were all contact printed so all are roughly 7½″ x 9½″ when trimmed. Whether the subject was a translucent shell printed larger than life-size or the Oceano Dunes, Weston's single print size seems admirably suited. There is a mysterious rightness in photographs visualized print-size on the ground glass.

A different approach is employed by Paul Strand. I understand that Strand often makes a group of prints of graduated size from a negative before deciding on the dimensions of the final exhibition print. When I viewed his retrospective exhibit in 1970 of over 500 prints, it was impossible for me to discern any pattern of sizing. Landscape, heads, full figures, and small forms in nature ranged in size from 5″ x 6″ contact prints to almost 11″ x 14″. Only a half-dozen landscapes were printed large, but none of these measured as much as 16″ x 20″. In all cases the prints seemed beautifully proportioned. Although Strand's flexible approach to the dilemma is contrary to Weston's (whose print sizes were dictated by his equipment), both men produced exquisite work.

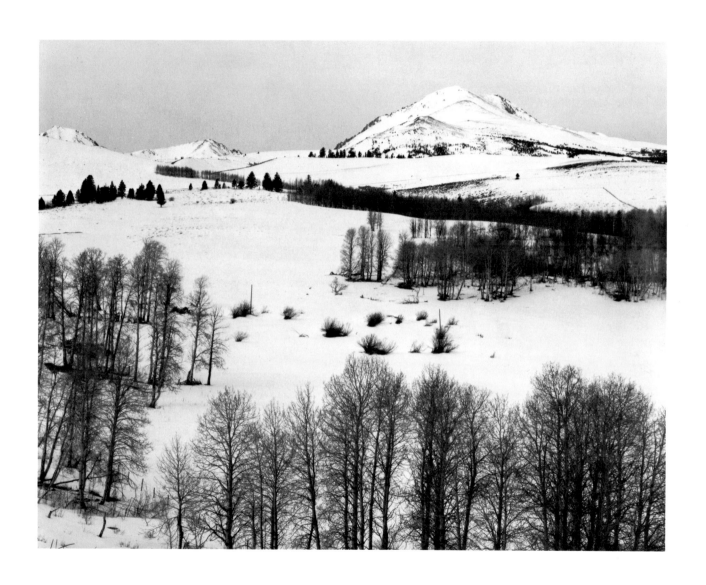

New Hampshire 1973

The flat, gray-white snow light is similar to that of the scene on p. 94. The impression here is more of solid pattern than space in depth. The entire format is covered with a "wall" of branches.

The thinner trees and branches might appear to be darker than the thicker trunks because of the smaller space they occupy in their white fields. (A thin dark line generally appears darker than a wide line of the same tone.) The horizontal branches at the upper left look almost black as do the tiny saplings at the lower right.

To preserve the whiteness of the snow, it was placed on Zone VIII. The largest tree trunk fell on Zone III and most of the other trees fell on about Zone IV. The rather low brightness range is typical of diffused skylight and snow. The snow reflects light up into areas that would normally be shadowed. There was no attempt to expand the existing tonal range in this photograph: A contrastier negative would have destroyed the ethereal luminosity characteristic of the woods, the light, and the new snow.

Photographs in the woods usually require small lens openings for adequate depth of field. The corollary to small openings is long exposure—especially in low light; and long exposure dictates windless days for woods scenes. The Sinar 4″ x 5″ camera was leveled to avoid convergence of the trees and the 210mm lens was raised to frame the desired area. The exposure was 1/10 sec. at $f/32$.

The 4″ x 5″ Tri-X negative was developed normally—i.e., five minutes—in HC-110 dilution B. It was printed without manipulation except for slight edge-burning at the left. The print shows a trace of tone in the foreground snow. Some of the snow on the branches prints pure white and touches of black appear in several of the small trees and branches.

Moai Easter Island, 1973

For this photograph I would have preferred to use a Minox camera as these carvings (*Moai*) were lying about 400 feet up a steep crater wall. Unfortunately, the subject demanded the versatility of the bellows camera on a sturdy tripod. Though fast-handling small cameras are capable of photographs that are beyond the scope of view cameras, they are not as well adapted to very exact composing and focusing. The large ground glass of the bellows camera allows the photographer to see very precisely. The rising front, the swings and tilts, permit distortion correction and great depth of field. The large negative can also reproduce nuances of tone and sharpness of definition that are lost when small negatives are enlarged.

Some loss in print quality occurs when even a 4″ x 5″ negative is enlarged. The very finest print quality is seen in a contact print from an 8″ x 10″ negative, but few photographers, myself included, are willing to pay the high equipment price and film cost or carry the very considerable weight. One 8″ x 10″ film holder weighs as much as a 35mm camera! Art Sinsabaugh regularly uses a 12″ x 20″ camera. He told me the film holders, which look like coffee table tops, cost $135.00 each. His 12″ x 20″ prints are exquisite and the format is perfectly suited to the flat Midwest landscapes that he photographs.

The 4″ x 5″ camera was used for this photograph. It was first leveled side to side and front to back. A true perspective is possible only if the camera back is vertical. In this situation such perspective was mandatory as the intended use of the photograph required scientific accuracy. Since the camera position was above the subject, the falling front was then utilized to include the desired area. If the camera pointed down, which would have been necessary with a hand camera, certain distortions would have occurred.

To achieve sharpness in depth without stopping down, the lens was tilted forward as the focus was adjusted until the nearest and farthest areas appeared sharp on the ground glass. I have found that magnifying eyeglasses are far superior for focusing view cameras than the small magnifying loupes in general use. With a loupe you can focus, for example, on the image at the bottom of the ground glass, but when you then move it to the top to correct that area, the bottom goes out of focus. The magnifying glasses not only allow you to see the entire ground glass magnified, but they also free both hands to manipulate the swing front or back as you focus. A prescription for magnifying lenses for close reading (about 4″) can only be determined by an optometrist. Magnifying glasses are also handy for spotting prints.

In order to show sufficient detail in the lying figures, they could not be safely placed lower than Zone IV. The sunlit grass fell on Zone VIII, which would ordinarily be too high; but the grass is sparse and quite broken up with small shadows, so the overall tone appears lower than the bright blades.

The exposure was 1/5 sec. at $f/22$ on Tri-X film developed normally. The print was made on Varigam with a No. $3\frac{1}{2}$ filter. This filter was needed to increase the contrast within the dark forms, but it also raised the print value of the sunlit grass. Subsequent burning-in through a No. 1 filter reduced the two sunlit areas to proper balance.

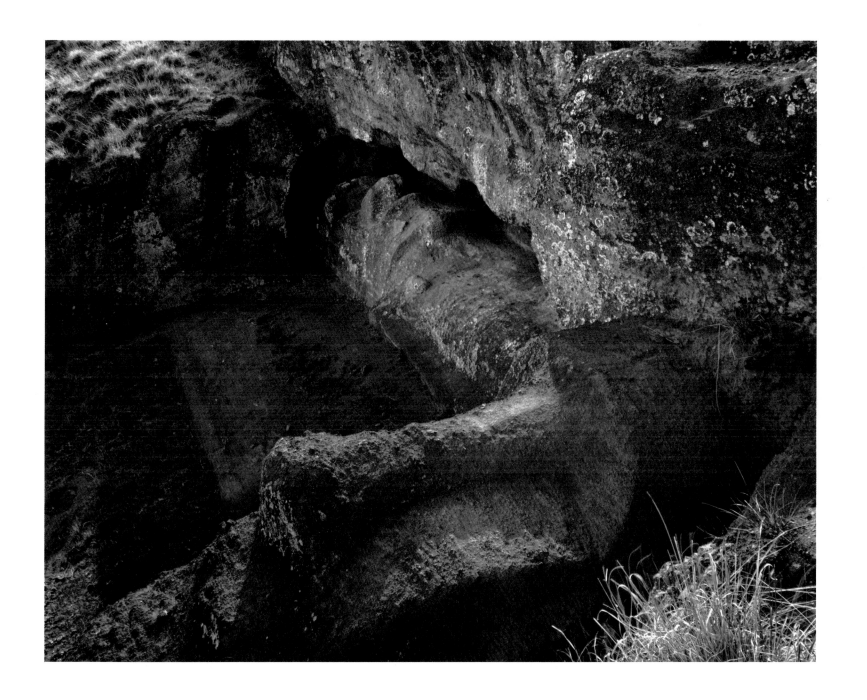

Bellows Falls, Vermont 1974

Extend both arms straight out to the side, wiggle your fingers, and you can see both hands simultaneously. Human vision is close to 180°—very "wide angle." Placing your hands side by side at reading distance and looking at your right hand, you can easily perceive your left hand, but not very sharply. Though we have wide-angle perception, the area of sharp lateral definition is small. Now, by placing your right hand one inch in front of your left and looking at either hand, the other is out of focus. Our "acceptable depth of sharp focus" is poor. In spite of these optical limitations, when looking at a large area we think we can see it all clearly and simultaneously. The illusion is a result of our rapidly scanning the scene, during which dozens of small area images are relayed to the brain and memorized to form an impression. We are pretty good at it, but through the lens or on the ground glass we can actually see (photographically speaking) better than with the naked eye.

Using this scene for an example, the area of the structure encompassed in the print is about 10 by 15 feet, and about 5 feet separates the front of the platform from the face of the building. When the camera was set up, the entire 150 square feet of the scene appeared on the 8″ x 10″ ground glass. The scanning area was greatly reduced, and many elements that are actually far apart were in such close physical relationship on the ground glass that framing, composing, and camera positioning were simplified. Additionally, the restricted frame removed distracting extraneous subject matter, so vision was further concentrated. Because the image is projected onto the flat ground glass, the eye has no depth of sharp focus adjustments to make. All of these concentrated optical effects occur with any camera, but if an 8″ x 10″ camera is employed (and the print is to be an 8″ x 10″ contact print), the effect is heightened. The only remaining important difference between the ground glass image as seen and the future black-and-white contact print is that the image is seen in color. Looking at the ground glass through a viewing filter reduces the colors to their approximate monotone print values. The camera itself has become an enormous aid to previsualization of the print. It should be said that all of the above is opinion—not very scientific—and there are many fine photographers who would dispute part or all of these conclusions and stoutly maintain that the camera is an obstruction to their seeing. But I am satisfied that I can often use the camera to sharpen my vision.

In the 8″ x 10″ print, the viewer also sees the scene compressed. It therefore appears clearer, more concentrated, more sharply detailed than the actual scene. Has the camera produced a super-reality? Is it possible that a photograph can be visually and emotionally more powerful than the scene photographed? Just as an enlarged image of a coin or a postage stamp results in startling revelation, so does a compressed image of a large area. If the photographic quality is such that exquisite nuances of line, tone, and texture are fully revealed through the contact print, we can understand Weston's meaning when he wrote in his daybook, 3/15/30, "I want the stark beauty that a lens can so exactly render, presented without interference."

The camera used was an 8″ x 10″ Sinar with 12″ Goerz Lens. The exposure was 1/25 sec., at f/32 on Tri-X sheet film, tray developed normally in HC-110 dilution B. The contact print was made on Ilfabrome No. 3 paper, developed five minutes in Dektol 1:2.

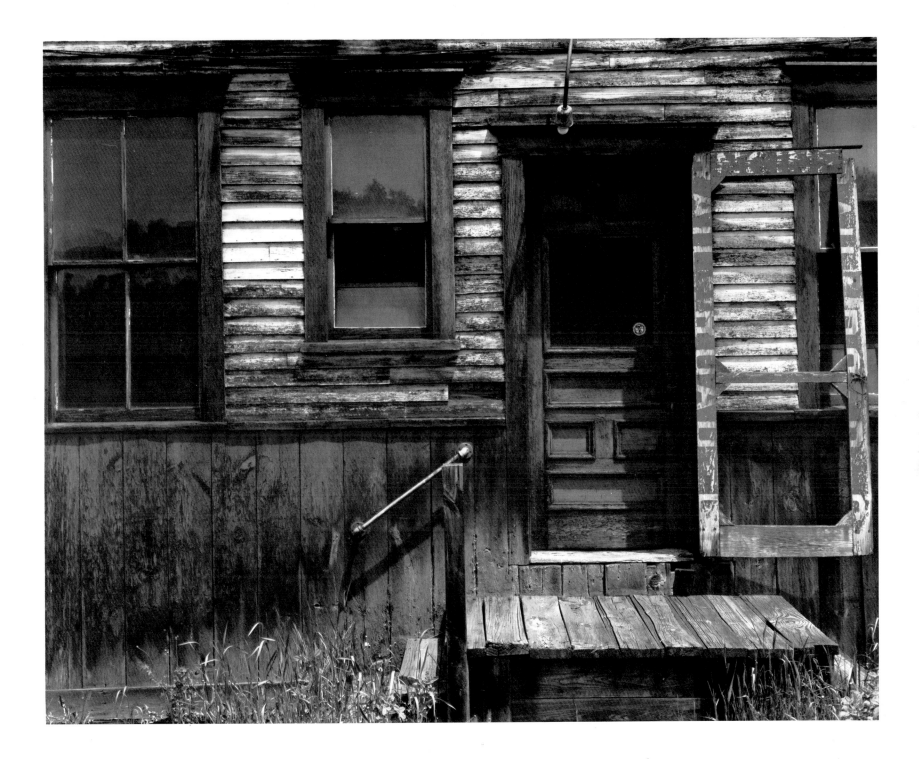

Gaspé 1972

Imagine you are outdoors looking at six panes of glass in a window. The sun glares back from the upper center pane. Moving your head a trifle to the right moves the reflection to the right-hand pane. You can make different designs simply by changing your position. In the same way, you can choose your camera position so that the sun's reflection in a pool is centered over a rock. By so placing the camera, you avoid a large area of glaring water surface; instead, the light-absorbing rock becomes the reflecting surface. If the reflecting area is larger than the rock, there will appear to be a "halo" of sparkling water around the rock.

Generally at midday the light source is overhead and reflections from water are seen in pools underfoot. On this gray day the sea was strangely brighter than the sky. The sea became a low-lying source of the reflections so that the far pool on the beach became the reflecting surface. Setting the camera in position to place the strongest reflection in the farthest pool, I also noticed in the ground glass that the foreground pool was cut in half. The rock was "shading" it from the sea—the light source. This close pool actually extends to the left print margin, but since the left part of its surface reflects no light, it cannot be seen in the photograph as water. The center pool is brighter than the nearest pool because it is closer to the maximum reflecting angle of the broad light source.

The values were placed for maximum printable density so that as much detail as possible could be held in the dark beach stones. The brightest reflecting pool was placed on Zone VIII, the sea fell on Zone VII, the center pool on Zone VI, the sky and near pool on Zone V, the top of the rock on Zone IV, and the beach stones and sea weed on Zone III. The lowest values appear at the base of the large rock. Exposure was probably about $\frac{1}{4}$ sec. at $f/32$. (The notes from this trip were lost.) The first Tri-X negative exposed was marked for normal development. Then it occurred to me that the reflecting pool should not be a Zone VIII value at all. Because of its small size it could glare pure white to add a touch of brilliance to this gray day. Another negative was exposed and designated Normal +1. The +1 development raised the Zone VIII placement to a Zone IX density.

The print was made from the second negative on Varigam without a filter. The sky and water were darkened slightly to make the reflecting pool appear even brighter. The reproduction was later used on invitations to a New York exhibit called, "New England and the Maritimes."

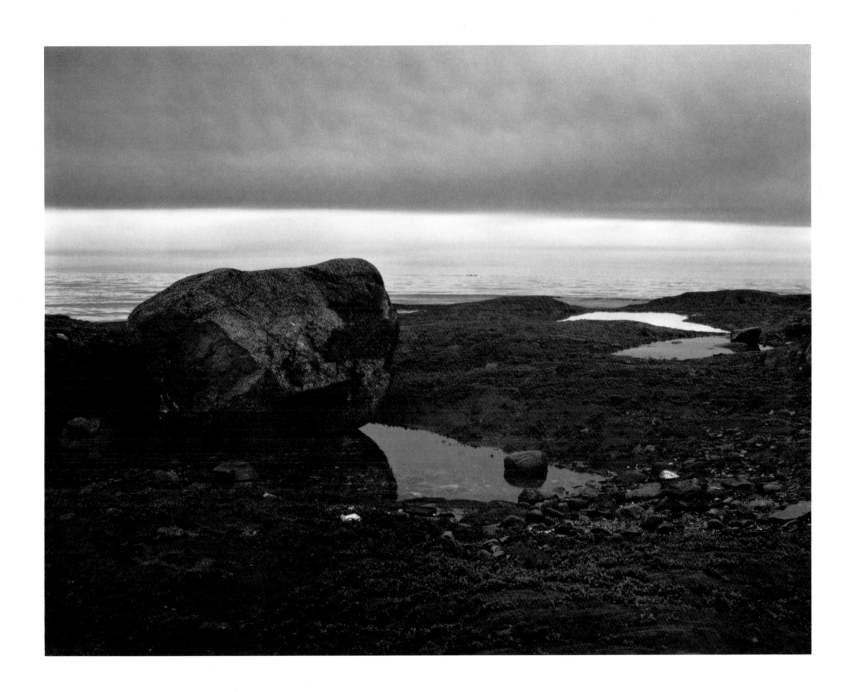

Victoria Rapahango, Tepuku Easter Island, 1973

More film has been used to record the human face than for all other purposes combined. People just love to look at people and pictures of people are very easy to make. The subject is generally accessible and cooperative and can be moved, lighted, and composed. Techniques vary from the quick candid, in which the subject is unaware that his picture is taken, to the studio setup complete with artificial backgrounds, makeup man, and flash equipment. Even the facial expression is under the photographer's control: "C'mon, Billy, smile," and for the executive portrait, "Please pick up the phone and look seriously over my left shoulder."

In spite of the sheer volume of portraiture, searching photographic studies of individuals are not too common. A portrait describes how a certain person appeared to an individual photographer from a certain angle under certain lighting conditions at a certain 1/60 of a second during both of their lives. The viewer of the photograph has no way of knowing if this moment is typical or unusual or in any way indicative of the deeper aspects of the subject's character. The subject's impression of himself is often much different from the photographer's impression and the photograph the subject chooses from a group of proofs is usually not the picture the photographer would have chosen. The photographer, therefore, bears a heavy responsibility when he selects a portrait that will be widely distributed.

The proof sheet shows a group of pictures of Victoria Rapahango made while she was engaged in conversation. She is a leading personality of Easter Island, a local historian and unofficial record keeper of all births, marriages, and deaths. She is a descendant of Island nobility. Her manner is gracious and elegant, her bearing is self-assured and dignified.

Madame Rapahango is the widow of an Englishman, so there was no language problem and we were able to establish an easy rapport during the amiable hour we spent together. During that time, I made about 20 photographs. None of these could convey the richness of her 80 years or the wealth of her accomplishments. The picture I finally selected seemed to come closest to my sense of her personality.

The photographs were made with a Nikon camera fitted with a 105mm lens. The flesh tones were placed on Zone VI and the exposure was for 1/60 sec. at $f/8$. The Tri-X negatives were developed as usual in HC-110 dilution B for five minutes at 68°. The print was made on Varigam VGTW paper, Grade 2 (no filter), and developed two minutes in Dektol diluted 1:2. The face was dodged for about 25% of the total enlarging exposure.

The picture shows how Victoria Rapahango looked during 1/60 of a second one afternoon in April, 1973.

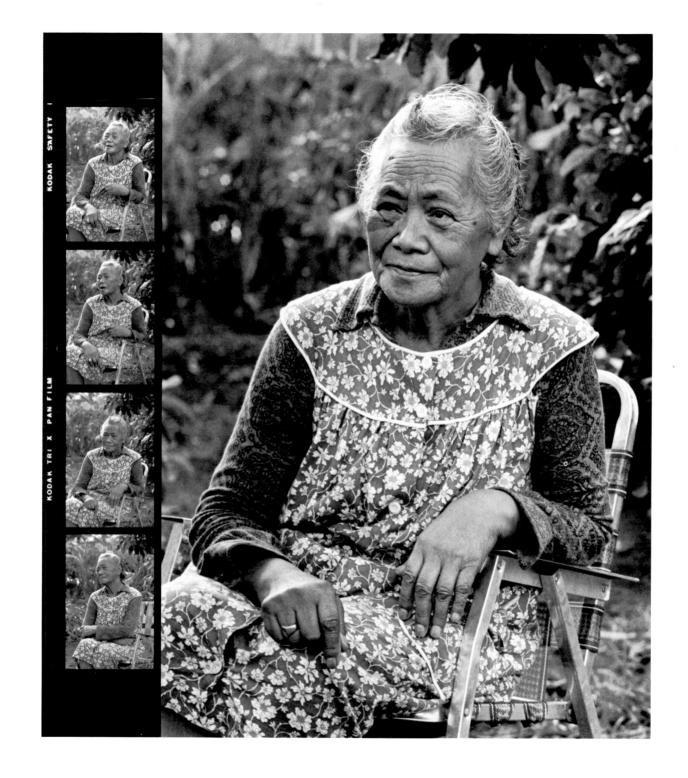

Pemaquid, Maine 1973

The print opposite is the only one I have made with a condenser enlarger in many years. The distortion that unnaturally affects the high values is perfect for this picture, which was a planned departure from reality. Comparison of this print with the contact print shown above will help clarify the following discussion.

The small dark shadow at the upper left was visualized as print value Zone 0—maximum black; the mass of rock as Zone III—deep mysterious tones with some separation; the slice of white stone would be Zone VIII—white. Meter readings showed that the reflectances did not coincide with my conception. When the small dark shadow was placed on 0, the gray rock fell on IV and the white rock only on VII. A plus development would increase the white rock to VIII, but it would also increase the gray rock to almost V. The desired value was Zone II for the gray rock. If contact printed as shown, or printed with cold light, the negative densities would be accurately recreated as print values; but with the condenser head, the high value would block and the low values could be printed as dark as desired.

The white rock was therefore placed on VIII where no amount of condenser printing would affect it. The gray rock fell on V, but increased printing time (printing down) would reduce it to Zone III. The overprinting would also make the shadow maximum black.

A Sinar 4″ x 5″ camera with a 210mm (8¼″) Symmar lens was used; the camera back was tipped to the rear for sharp focus. Placements were made as described and the exposure was 1/25 sec. at ƒ/22 on Tri-X film developed normal in HC-110 dilution B. A 7″ x 9″ print was made with the condenser enlarger on Varigam Grade 2 paper, which was toned for about 20 minutes in selenium mixed 1:60. The blue-black tone of the original print gives the appearance of nebulae floating in a dark sky.

Leon Tuki Hei Easter Island, 1973

I spent a month in Mr. Tuki's house while photographing for the book *Rapa Nui*. On the first morning of my stay he smiled, nodded, and gestured in a way reminiscent of a waiter who wants to know if everything is all right. Summoning up most of my high-school Spanish and spreading thumb and forefinger as far apart as possible, I said, "Mucho cucaracha, muy grande." He smiled and said in his only English, "No problem," and as it turned out, he was right. After a few weeks in that lonely place it was nice to hear the patter of their feet on returning to my room after a long day spent on a cast-iron saddle.

Leon is one of the few direct descendants of the early Island people, and he has a great store of knowledge of the Island's history and legends.

Leon is also an artist. He spends his days seated cross-legged on the floor of a tiny shed swapping stories with one or more cronies while he carves magnificent pieces in wood and stone. His only tool is a chisel 18 inches long with a blade nearly two inches wide. With the handle resting in the crook of his arm, holding the blade like a pencil, he can make a tiny, intricately figured pendant. For a farewell gift he presented me with a large, stylishly designed and beautifully executed replica of a *Moai*, the huge statues for which Easter Island is famous.

Perhaps more searching portraits are possible when the sitter is comparatively unconcerned with personal appearance. Urban man is bombarded by photographs of his and other faces. He constantly sees people in film and on television and he imagines how he would like to look; he often assumes a mask-like affectation before the camera. Nowhere is this difference between the urban and the less sophisticated more clearly seen than in the extraordinary human studies by Paul Strand. Strand's Egyptian Fellah, the blind woman, and the crofters of the remote Hebrides convey their humanity with the purity of the innocent.

The photograph was a pleasure to make. Leon sat patiently while I fussed with meter, film, and focus and then looked straight into the lens when I asked him to. I used a 4″ x 5″ camera and 210mm lens set for 1/25 sec. at $f/32$. The meter indicated that the white shirt would fall on Zone IX when the flesh tones were placed on Zone VI. The Tri-X film received a minus development to reduce the brilliant white shirt to Zone VIII density.

The original 7″ x 9″ print contains delicate value progressions in the black pants and white shirt that may not be apparent in this halftone reproduction. It was made on Varigam paper with a No. 1½ filter to soften it slightly. Printing controls included the addition of 20% exposure while the face was shielded by a small dodger. Edges were then burned an additional 10% about one inch from the margins.

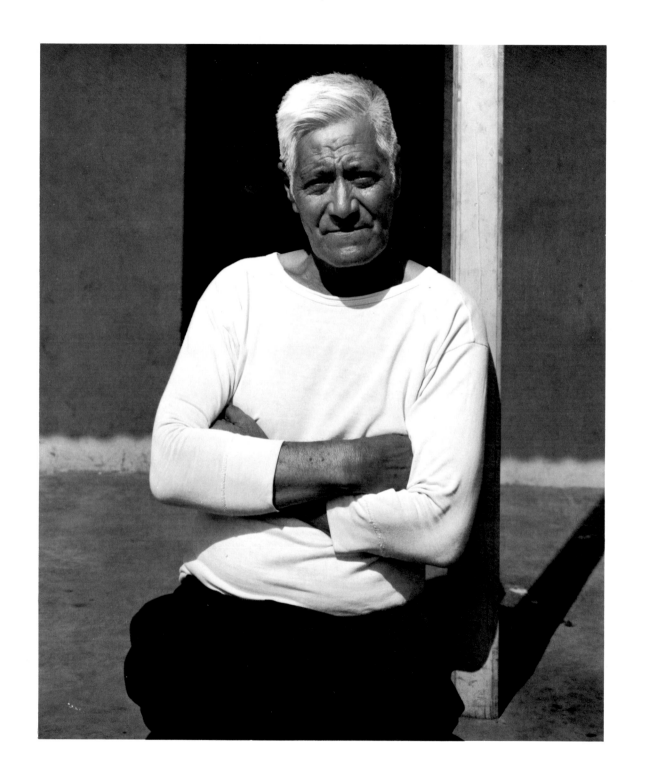

Barbara Sherman, Connecticut, 1969

No cheaper, more available, or more attractive portrait lighting exists than that provided by the open sky. In open shade or on an overcast day subtleties of modeling and texture are assured. The photographer has no problems with hard shadows and the sitter is more relaxed in the soft light.

This portrait was made with a Nikon 35mm camera and a 105mm lens on Tri-X film. The hand-held camera has great advantages over larger cameras when a number of informal exposures are required. There are two problems that should be recognized: the small negative size and the possibility of camera movement (since the camera is hand-held). Fortunately, the very fast lenses for small-format cameras permit wide apertures with fast shutter speeds. In this case, $f/4$ at 1/60 sec. was sufficient to freeze camera and subject movement and provide sufficient depth of field.

For acceptable print quality, the small negative must be utilized fully. Paradoxically, users of slow-handling large cameras almost always compose their images tightly and utilize the full negative in their prints, while many 35mm users crop the small negatives. This may be necessary with fast-breaking action, but in a controlled situation such as shown here every effort should be made to use all of the available negative area. Enlargement ratio is surely one of the greatest factors in loss of image quality, as a comparison between an 8″ x 10″ and an 11″ x 14″ print will clearly show. Full negative utilization for portraits generally requires a vertical format.

With long lenses at wide apertures, precise focusing is critical. Focusing on the subject's eye that is closest to the camera is a good rule. After focusing on the eye, the photographer using a 35mm camera with a focusing microprism or split-image finder in the center must then move the camera if full utilization of the negative is to be accomplished. If he exposes when the eye is focused upon, he will leave a large, unused area at the top of the image field. In this photograph, the camera was tilted down after focusing on the eye; the mouth therefore appears in the center of the format and there is no wasted area at the top.

Cold light for enlarging small negatives is as advantageous as it is for large negatives. The more pleasing grain structure without loss of sharpness is sufficient reward. But the greatest difference between cold light and condenser enlargers is the vast improvement in gradation. Flesh-tone highlights do not "break" from "chalk" to "soot," but blend smoothly and naturally, if the cold light enlarger is used.

Many photographers debate the merits of materials, chemistry, and hardware without first-hand knowledge. They could settle the question by merely making two identical photographs on different films, developing with different developers, and printing the results. My tests have shown that Tri-X developed in HC-110 consistently delivers the sort of smooth negative that adds a noticeable feeling of light and substance to the print.

Yankee Stadium New York, 1967

Earl Morrall, Number 11, the New York Giants' quarterback, is about to throw a touchdown against the Dallas Cowboys. Aaron Thomas, who has partially entered the picture, will be the receiver. Without the blurred figure of Thomas the picture would look almost posed with little indication of the speed and movement of the game.

The photograph was made with a Nikon camera and a 105mm lens. The exposure was probably 1/125 sec. at $f/11$ on Tri-X film, which was overdeveloped by the newspaper lab. In spite of the low contrast of the shaded scene, the overdevelopment so increased the contrast that soft paper was required. The print had to be made on Varigam with No. 1 filtration.

I spent a season photographing the Giants on Sundays when they played at home. Though I still don't regard myself as a sports photographer, there were a few points I learned from the old pros. One of these points is that it is important to know the game being photographed. For example, this was a third-down play, a "passing situation" in that more than three yards were needed for a first down. I was therefore standing at the back of the end zone anticipating a pass. If the pass had gone to either sideline, however, some other photographer would have recorded the touchdown. Luck is also important.

Timing is, perhaps, the most critical element of all. In this photograph, if the shutter had been released a split second later, the receiver's hand would have hidden the ball and his body would have covered Number 78, who adds movement and flavor. That kind of timing also has its element of luck, but the odds are improved if lots of film is used. During a football game 300 to 600 exposures are normal for a sports photographer.

Specialized equipment, of course, can be a great help. One Sunday I got a fine close-up of a receiver apparently catching a pass just as he was being tackled. In a flash the ball popped up and was intercepted. The photographer standing next to me had a motor-operated camera, and it kept exposing two or three frames per second as long as the button was held down. The real play here was the interception, and the photographer with the motor drive on his camera captured the entire sequence.

Sports photography is very fine training for fast camera handling. You quickly learn which way to turn the lens for focus without looking and which way to turn the aperture and speed settings as the play moves from sunlit to shaded parts of the stadium. Exposure can be predetermined by a reading of flesh tone—your palm—and placing it on Zone VI. If the reading was made in the sun, open two stops from that setting if the action moves into the shade. Experienced sports and news photographers never underexpose. Exposure errors, when made, are always in the direction of overexposure. The practical aspect of such thinking is that if it isn't on the film, you can't get a print. Overexposed negatives can be bleached if necessary and the loss of print quality is of little importance when a picture is to be used for newspaper reproduction.

New York City 1968

Street photography is like hunting; the trophies are pictures of found happenings in the city. Lartigue, Cartier-Bresson, Kertész, and others have depicted with humor and sympathy the fascinating juxtapositions of people relative to each other and their environment. Their pictures are often like quick quotations out of context, innocent of preachment or social significance. Other street photographs reveal the photographer's concern with the deterioration of urban life, or other social phenomena.

The 35mm camera is usually chosen for street photography. If you are shy about approaching strangers directly, a moderate telephoto lens will allow a more discreet viewpoint.

This photograph was made with a Nikon camera and a 105mm lens. I saw these four people and immediately retreated out of their view to determine exposure. A reading of my palm was placed on Zone VI. (The palm must be in the same light—sun or shade—as the subject. It must also be at the same reflective angle—in this case, vertical—and the meter reading should be made in the camera-to-subject direction.) All similar reflecting surfaces, such as the faces, would therefore also appear on Zone VI. The face over the sun reflector would probably fall on Zone VII or a bit higher. After setting the shutter at 1/125 sec. and the aperture at $f/8$ for the Panatomic-X film, I strolled to a predetermined spot and focused on a tree that was off to the right but the same distance away as the group.

The man watched unconcerned as he thought I was photographing the tree. All that was then required was to swing the camera to frame the scene and quickly trip the shutter. When I did, the man immediately stood up and walked away, the woman lowered the reflector . . . the picture disappeared!

Panatomic-X film is very sharp and fine-grained and is fast enough for hand-held exposures on sunny days. It was developed in FRX-22 for 11 minutes. The print on Kodabromide No. 2, from which this reproduction was made, is the only one I have. The picture was awarded Third Place in the 1969 Nikon contest, but the Nikon people would not give me the prize (a lens) unless they could see the negative. They sent the lens, but would not return the negative.

Moral: Never lend a negative.

White Plains, New York 1972

Steichen's searching studies of a Shadblow tree, Caponigro's beautiful Redding Woods series, and the Point Lobos photographs of Edward Weston were made within a few steps of each photographer's door. The photographer can often achieve a greater intimacy and power in pictures of areas well known to him than in pictures of seemingly more dramatic but less familiar subject matter.

The woods behind my former home in White Plains were very lovely, but my early attempts to record them were disappointing. After a few years, the area became more familiar, more intimate, and easier to understand.

This view is from a raised deck at the back of my house, about an hour after a rain. The tree trunks are still wet and record much darker than if they had been dry. The thin branches are brighter than the trunks as they dry more quickly and, because they are being photographed from above, they are also reflecting the open skylight. Note that the high camera position places the bright branches against the middle tone of the forest floor. A ground-level camera position would have allowed the branches to merge with the sky, as is happening in the upper right-hand corner.

The dark trunks were placed on Zone II, the bright branches, metered with the $\frac{1}{2}°$ S.E.I. meter, fell on Zone VI but were developed to Zone VII—Normal +1. The print was made on Varigam with a No. 3 filter, which expanded the print value of the branches to Zone VIII. This departure from reality—the meter's reality—is to me a closer representation of the emotional effect of the original scene.

The 4″ x 5″ camera with 121mm lens was leveled and the drop front and rising back were employed to frame the scene. If the camera had been pointed down, the trees would have leaned outward. If the camera was level and all settings were at zero, as with a fixed-lens camera, the horizon line, which is near the top, would have appeared across the center of the print.

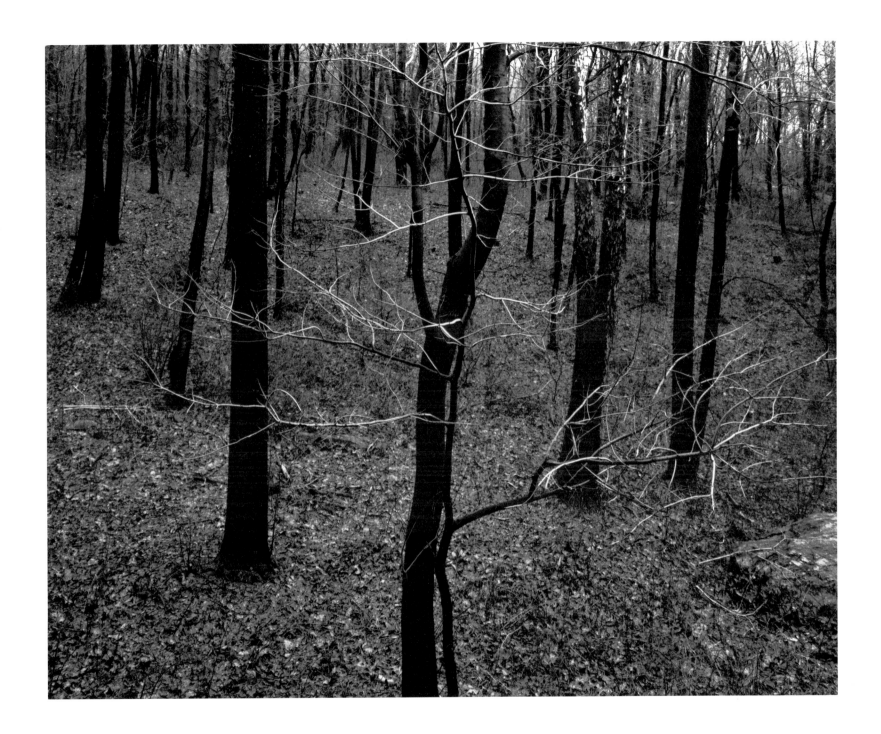

White Plains, New York 1970

The exposure was made during a soft spring rain with the camera set up in my kitchen before an open window. Focus with the view camera was determined by an initial adjustment to show the nearest raindrops and the farthest trees equally unsharp with the lens open. Then the lens was gradually stopped down while the focus was slightly adjusted until both the near and far subjects were sharp on the ground glass.

A simpler technique for focusing is available with hand cameras, which have distance indications on their lenses. For example, a 35mm lens on a 35mm camera can be adjusted to a depth of field extending from $4\frac{1}{2}$ feet to infinity if set at $f/16$, its smallest aperture. By setting the lens at $4\frac{1}{2}$ feet the photographer can move backward and forward until the nearest part of the subject is sharp, then set the lens to the point where both $4\frac{1}{2}$ feet and infinity are within the $f/16$ markers. In this case the focused distance would be ten feet; this setting will render acceptable sharpness over the entire subject area. Of course, $f/16$ is not the sharpest opening for a lens of this size; but if the photographer is to retain sharpness in depth, he must stop down. Note: All lenses of a given focal length have exactly the same depth of field at a given aperture regardless of brand or price.

If a subject requires more depth of field than the available lens is capable of covering, the camera may be moved back to include all areas within the depth of field marks on the lens. The print can then be cropped to remove the extraneous areas. If moving back is impossible, I believe that the nearest part of the subject should be rendered sharply at the expense of the distant planes. Nothing is more annoying to me than the out-of-focus tufts of leaves and branches that so many photographers employ to "frame" their compositions.

This photograph was made from a distance of six feet to the nearest twigs of the birch tree. The lens opening required to include the twigs and distant trees with acceptable sharpness was $f/32$ for a 121mm lens used with a 4" x 5" format. With the focusing point at seven feet and the aperture at $f/32$, adequate sharpness is possible from $3\frac{1}{2}$ feet to infinity.

The exposure required to place the dark trunks on Zone III was one second on the Tri-X film. The leaves on the ground fell on Zone V, the birch tree on Zone VII. The negative was developed normally, but a print on No. 2 paper seemed depressed and heavy. The final print, on Varigam with a No. 3 filter, recaptured the feeling of the gentle light.

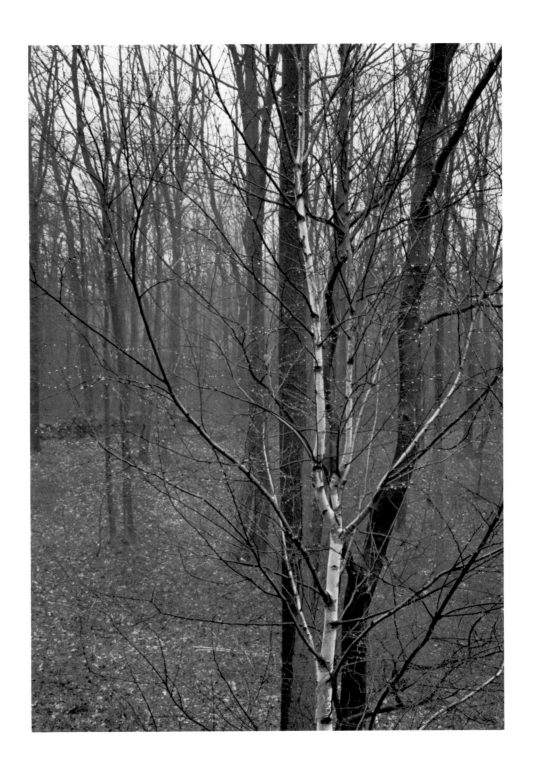

White Plains, New York 1970

This great old beech tree stands in the woods that crowd my house. It was already of considerable size when some long-forgotten farmer built the stone wall that terminates at its base. "B. H." carved his initials on the trunk in 1921. I have taken many pictures of this tree and am including several of them here and in the next few pages: A subject of strong and variable character traits—whether a tree or a person—deserves and requires more than a single image if it is to be known more than superficially.

This photograph was made with a 121mm lens on 4″ x 5″ Tri-X film developed normally in HC-110 and printed with slight edge burning on No. 2 Ilfabrome. The print developer used was Ardol, which accentuates the warm tone and open shadows appropriate to the scene.

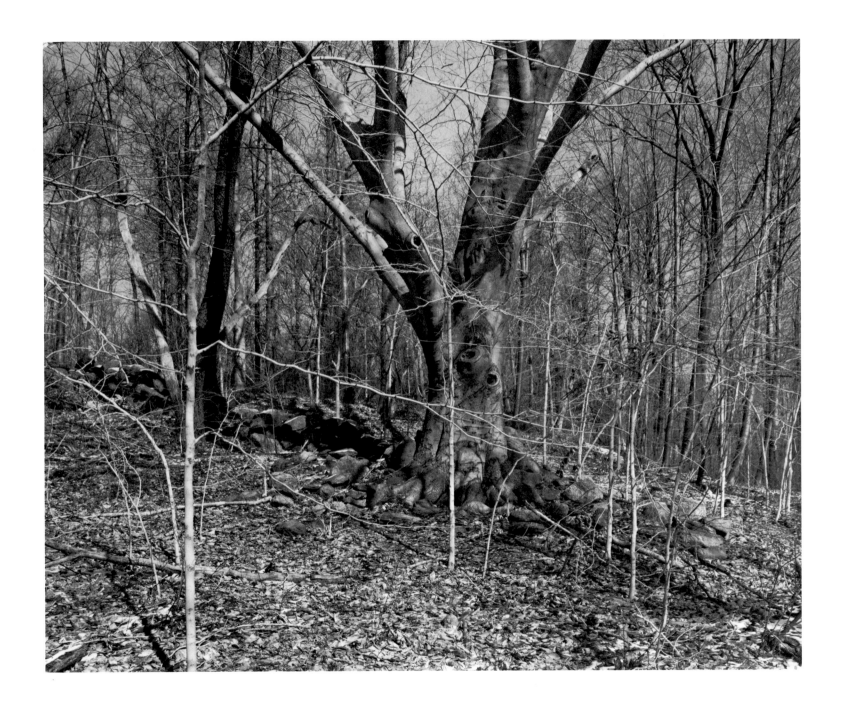

White Plains, New York 1974

A 4″ x 5″ Sinar camera with bag bellows and 90mm Super Angulon lens without filter was used here. The rising front made it possible to include the upper part of the tree without tilting the camera upward.

The sunlit snow was placed on Zone VIII, shaded snow fell between Zone V and VI, the wet areas of the tree trunk fell on Zone III, and black appears at the base of the tree and in seams in the bark. A monochromatic viewing filter was used to study the relationship of the sky tones to the branches. It showed that further darkening of the sky through filtration would be undesirable, because a tonal merger between the branches and the sky would occur.

The indicated exposure was 1/30 sec. at f/32 for the Tri-X film, which I rate at 200 when I use my S.E.I. meter. Development time was my normal five minutes in HC-110, dilution B, with constant agitation in a tray.

Kodak's recommended development time is nine minutes. It seems to me, however, that nine minutes (one minute longer than my Normal +1 time) would yield a negative impossible to print well because of blocked high values. With condenser enlargement, which reproduces all values above Zone VI about $1\frac{1}{2}$ Zones higher than they would appear in a contact or cold-light print, the problem would be even greater.

The upper part of the tree and the sky appeared unnaturally dark in the straight pilot print. This was the result of the severely raised lens position when the negative was made.

When the lens axis is displaced far off the center of the film, the lens-to-film distance is greater for one part of the film than the other. This added distance is equivalent to added bellows extension, which in this case would reduce the exposure for the upper part of the image. It is usually a good idea to increase exposure by a half-stop under these circumstances; this would theoretically result in a half-stop overexposure for the lower part of the image. In this case, the lower part of the image was the snow, and it had been placed on Zone VIII. Therefore, this added exposure could not be given and the adjustment had to be made in the print.

The 8″ x 10″ print required an eight-second enlarging exposure on Ilfabrome No 2. The timer was set for two seconds and the upper third of the print was dodged with a card for one of the two-second periods. After the next three two-second bursts, which covered the entire print, an additional two seconds of exposure were added to the lower corners, which looked a bit weak.

The print was made on the Ilfabrome paper designated "Velvet Luster." This has a bright, smooth finish, but it is not as slick as Ilfabrome's glossy finish. The tone is warm and rich with no trace of the olive tone that many other papers show. Selenium toning has little effect on this paper's color, but selenium or gold toning is required for archival processing. The silver of the image is actually converted to longer-lasting selenium or gold when prints are toned.

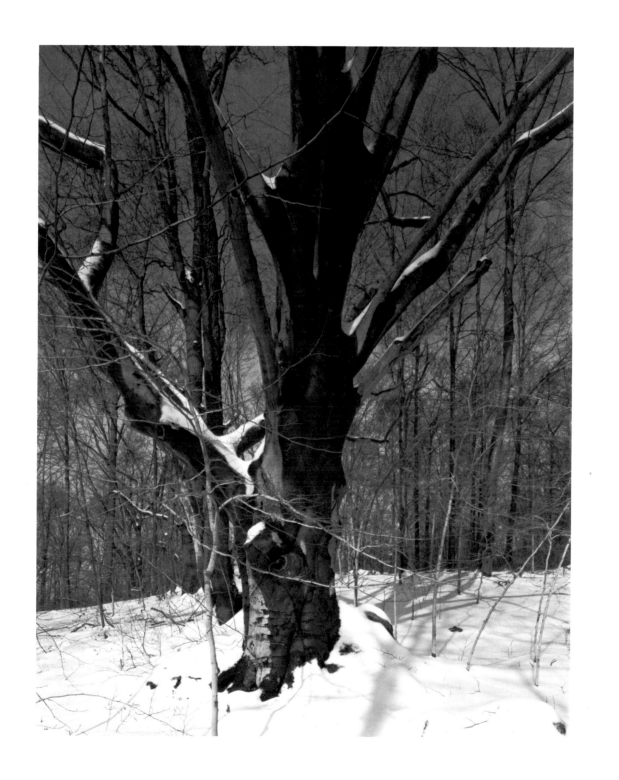

White Plains, New York 1973

The heavy musculature of the beech tree is accentuated by the insubstantial fallen leaves. The root at the right of the photograph has been forced over the unyielding rock in its search for receptive ground. Even within the trunk and roots, the rough textured dark shapes contrast with the smooth unbroken lighter bark to create their own tonal and textural forms.

The photograph is composed of middle grays. There is no value higher than Zone VI and the tones are keyed only by the black seams between the roots. Here an averaging meter would have indicated the exposure actually used if the user was without knowledge of the Zone System. The average reflectance of the entire area is a Zone V gray. The exposure for the Zone V placement in predawn light was one second at $f/45$. The 121mm Super Angulon lens and 4″ x 5″ Sinar were used; the camera was about three feet from the tree and about two feet above the ground.

The negative was developed normally and a "straight" print was made, except for the usual 10% added exposure for the edges. The Dektol developer was modified by the addition of bromide, which increases contrast by retarding development in the higher values. The No. 2 Ilfabrome paper was developed four minutes.

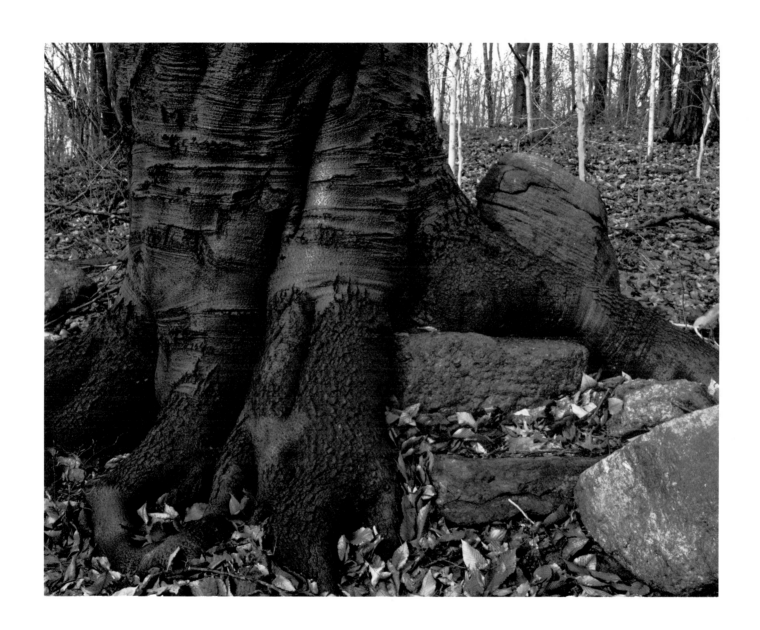

Exercise

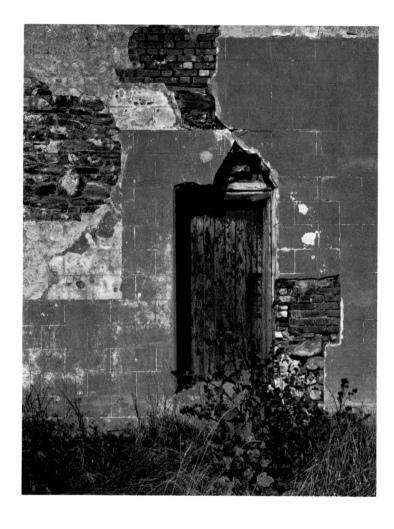

During the print-making process, after test strip exposures are completed and the proper printing exposure is estimated, an unmanipulated pilot print is made. This straight print is studied for variations of paper, exposure, development, and manipulation that will lead through subsequent trials to a fine print. The pilot print and the several prints that follow are usually thrown away. There is, however, an alternative to this procedure: here is a worthwhile exercise that can be performed with prints before they are discarded.

The object is to find as many small complete images as possible. Cut out the ones you see with scissors. This will not only help you see the values and forms in each image, but more importantly, it will train your eye to search out and spatially relate tiny areas—an ability that will enrich future photographs.

As the accompanying example indicates, the mini-prints can be of any size or shape. This game has no rules other than the limits of your imagination. Practicing seeing in this way is stimulating and will prove to be surprisingly rewarding in your work. You might begin by studying each print in the following section not only as a whole, but for its smaller images.

Personal Photographs

Those photographs that are the most important to me are those that seem to take themselves. Paul Caponigro (in *Aperture*, 13:1, 1967) has described the phenomenon that leads to such pictures with insight and sensitivity:

"Of all my photographs, the ones that have the most meaning for me are those I was moved to make from a certain vantage point, at a certain moment and no other, and for which I did not draw on my abilities to fabricate a picture, composition-wise or other-wise. You might say that I was taken in. Who or what takes one to a vantage point or moves one at a certain moment is a mystery to me. I have always felt after such experiences that there was more than myself involved. It is not chance. It happens often. In looking back at a particular picture and trying to recall the experience which led to it, that inexplicable element is still present. I have no other way to express what I mean than to say that more than myself is present. I cannot deny or put aside these subtle inner experiences. They are real. I feel and know them to be so. I cannot pass it off as wild imagination or hallucination. It is illusive, but the strength of it makes me yearn for it, as if trying to recall or remember an actual time, or place, or person, long past or forgotten. I hope, sometime in my life, to reach the source of it."

The following photographs are so strongly personal that I prefer to describe them in plain technical terminology.

CROTON, NEW YORK, 1970
Camera Equipment: 4″ x 5″ Sinar, 12″ Goerz Artar lens
Meter: Weston V
Placement: Lowest values, Zone I (highest values fell on Zone V)
Filtration: None
Exposure: 1/5 sec., f/22
Negative Material and Development: Tri-X, N+2 in HC-110B
Print Material, Procedure, and Development: Varigam with No. 4 filter developed two minutes in Dektol 1:1
Print Size: As reproduced here

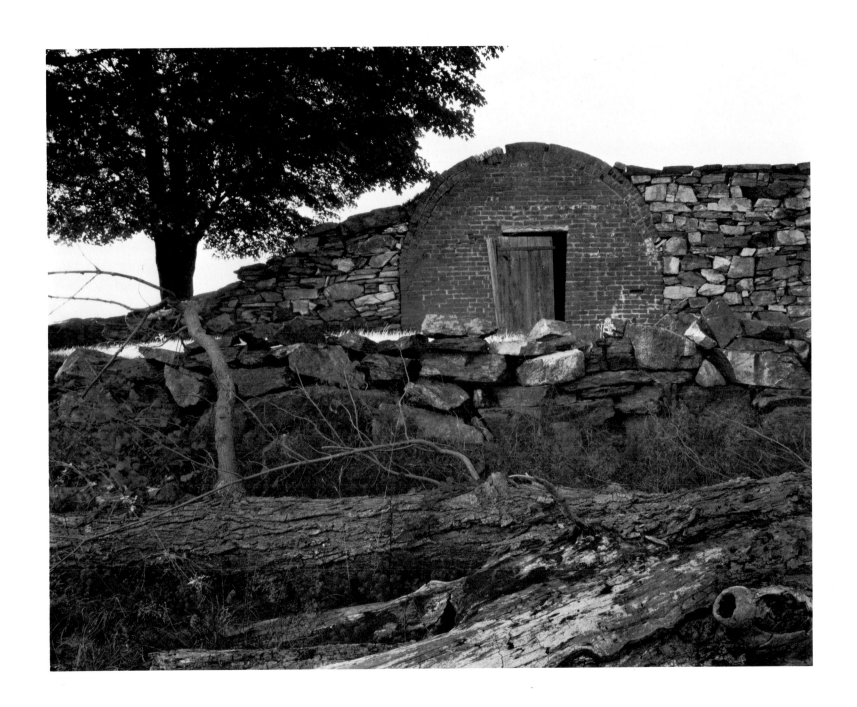

ROCKPORT, MASSACHUSETTS, 1974
Camera Equipment: 4″ x 5″ Sinar, 210mm Symmar lens
Meter: S.E.I.
Placement: Shadowed rock on Zone III, highest values fell on V and VI
Filtration: 25A, dark red
Exposure: 1/5 sec., *f*/16
Negative Material and Development: Tri-X developed N+1
Print Material, Procedure, and Development: Varigam, no filter, developed two minutes in Dektol 1:2
Print Size: 8″ x 10″

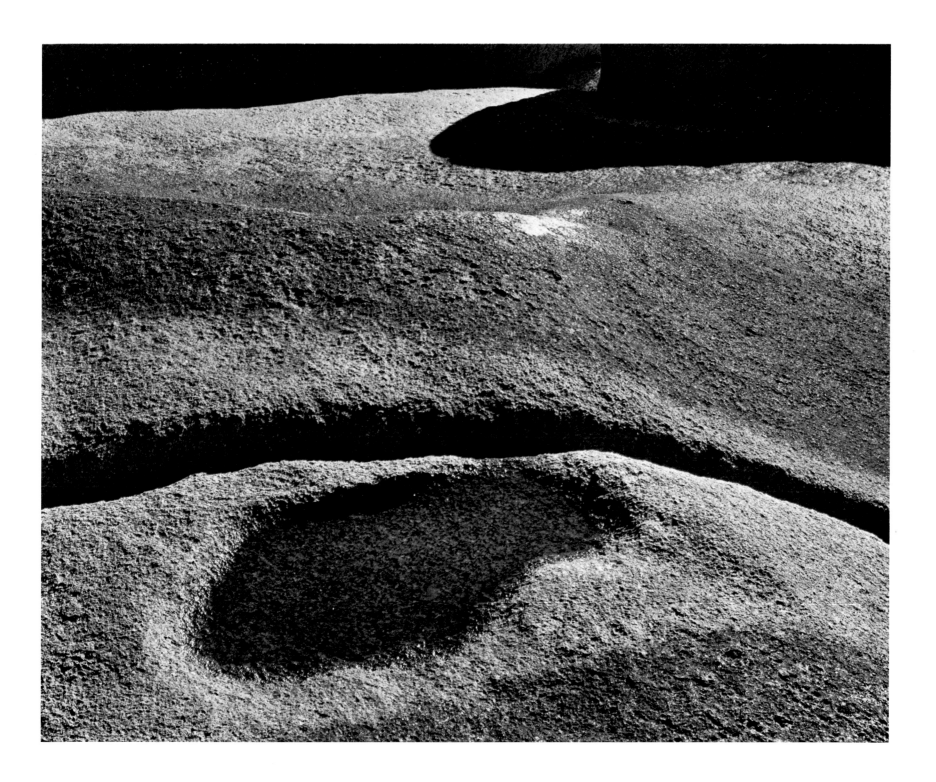

TOWNSHEND, VERMONT, 1974
Camera Equipment: 4″ x 5″ Sinar, 210mm Symmar lens
Meter: S.E.I.
Placement: Large trees on Zone IV, shadowed snow fell on V, sunlit snow fell on VII
Filtration: None
Exposure: 1/50 sec., f/32
Negative Material and Development: Tri-X developed N+1 in HC-110B
Print Material, Procedure, and Development: Ilfabrome No. 2 developed five minutes in Dektol 1:2
Print Size: As reproduced here

BAKER RIVER, NEW HAMPSHIRE, 1974
Camera Equipment: Pentax 6 x 7, 105mm lens
Meter: S.E.I.
Placement: Foreground rock on Zone II, sunlit white water fell on Zone IX
Filtration: None
Exposure: 1/125 sec., $f/11$
Negative Material and Development: Tri-X 120 developed N—1 (four minutes) in HC-110B
Print Material, Procedure, and Development: Ilfabrome No. 2, developed four minutes in Dektol 1:2
Print Size: 8″ x 10″

HOLDERNESS, NEW HAMPSHIRE, 1974
Camera Equipment: 4″ x 5″ Sinar, 12″ Goerz Artar lens
Meter: S.E.I.
Placement: Glassless center window on Zone 0, other windows fell on Zone I, sunlit cloth on Zone VI and VII
Filtration: None
Exposure: 1/125 sec., $f/22$
Negative Material and Development: Tri-X developed N+1 in HC-110B
Print Material, Procedure, and Development: Ilfabrome No. 2, four minutes in Dektol 1:2
Print Size: As reproduced here

WHITE PLAINS, NEW YORK, 1972
Camera Equipment: 4″ x 5″ Sinar, 121mm Super Angulon lens
Meter: Soligor 1°
Placement: Dark water on Zone II, rock fell on IV and V, highest value in ice fell on VII
Filtration: None
Exposure: 1/8 sec., f/32
Negative Material and Development: Tri-X developed N+1 in HC-110B
Print Material, Procedure, and Development: Varigam with No. 3 filter
Print Size: 8″ x 10″

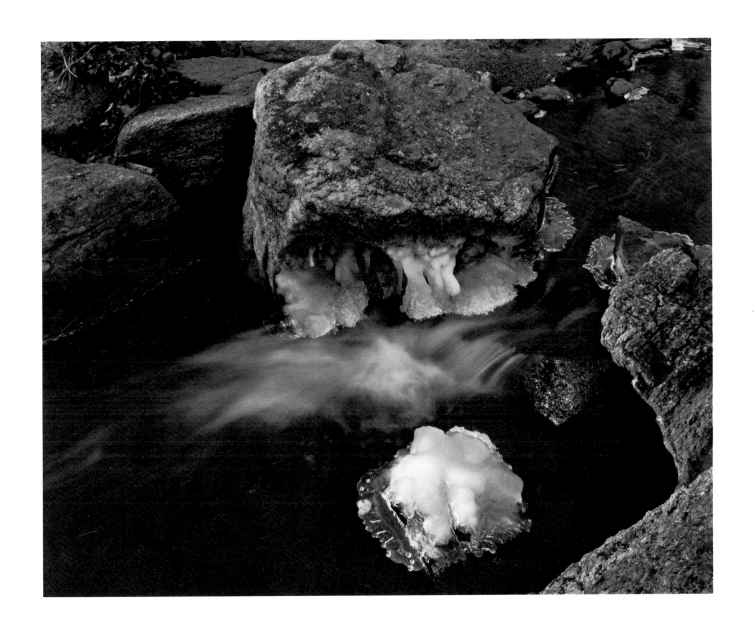

QUEBEC, 1972
Camera Equipment: 4″ x 5″ Sinar, 210mm Symmar lens
Meter: Soligor 1°
Placement: Dark water on Zone II, trees fell on V and VI
Filtration: None
Exposure: 1/8 sec., *f*/32
Negative Material and Development: Tri-X developed N+1 in HC-110B
Print Material, Procedure, and Development: Varigam with No. 3 filter developed two minutes in Dektol 1:2
Print Size: 10½″ x 13½″

HOLMES, NEW YORK, 1973
Camera Equipment: 4″ x 5″ Sinar, 121mm Super Angulon lens
Meter: S.E.I.
Placement: Darkest large areas on Zone II and III, the lighter areas fell on V, VI, and VII
Filtration: None
Exposure: 1/15 sec., f/32
Negative Material and Development: Tri-X developed Normal in HC-110B
Print Material, Procedure, and Development: Ilfabrome No. 3 developed 2½ minutes in Bromophen diluted 1:3
Print Size: 8″ x 10″

PATTERSON, NEW YORK, 1973
Camera Equipment: 4″ x 5″ Sinar, 300mm Goerz Artar lens
Meter: S.E.I.
Placement: Dark water on Zone I and II, ice fell on VI and VII
Filtration: None
Exposure: 1/10 sec., ƒ/22
Negative Material and Development: Tri-X developed N+1, HC-110B
Print Material, Procedure, and Development: No. 3 Ilfabrome developed two minutes in Dektol 1:2
Print Size: As reproduced here

Summary

Each situation, each subject, requires individual handling if the photographer's visualization is to be confirmed in the print. Various approaches were discussed as they applied to the individual photographs, but it might be helpful to review some basic equipment required, technical procedures, and materials.

CAMERAS

When a person asks, "What kind of camera should I buy?" I respond with, "What do you want to photograph?" Many photographers purchase, struggle with, and ultimately dispose of cameras that are not designed for the kind of work the photographer really wishes to do. If the photographer is interested in a fast-handling camera for street, sports, and wildlife photography, candid portraiture, color slides, and so on, I suggest a 35mm camera. This camera can be utilized in those situations where a tripod would limit needed flexibility. For the photographer who wishes to concentrate on landscapes, small forms in nature, architecture, and any other subject matter that allows the use of a tripod, I would recommend the classic 4″ x 5″, 5″ x 7″, or 8″ x 10″ view camera. With its swings, tilts, and interchangeable lenses, it is the most versatile camera available and its large negatives provide the finest print quality.

I think of the $2\frac{1}{4}$″ x $2\frac{1}{4}$″ cameras as an in-between alternate to either of the above. Although they do not handle as quickly as the 35mm cameras, they do provide a superior negative. Due to the smaller negative and lack of camera controls, these cameras do not provide the flexibility and print quality of a view camera, but they are certainly lighter and more convenient to use. Print quality improves more between $2\frac{1}{4}$″ and 4″ x 5″ negatives than it does between 35mm and $2\frac{1}{4}$″.

METERS

The most precise meter in general use is the S.E.I. photometer. This meter is calibrated to a standard mark each time it is used, cancelling out any variance of battery age, temperature, and so on. It projects a $\frac{1}{2}°$ dot of light on the subject that can be viewed through the meter. Rotating the meter's base slides two opposed, wedge-shaped neutral-density filters across the beam of light. When these filters reach a position where the meter light appears to match the subject tone (i.e., the light "disappears"), then shutter speed and aperture combinations are read from the scale on the meter. This instrument costs about $260 at the time of this writing, but is the only metering apparatus, except for even more expensive ciné meters, that will invariably provide the correct answer to the exposure question regardless of the situation.

My second choice is the CdS spot meter with viewfinder. With such meters as the 1° Pentax or Soligor, small areas can be metered from the camera position. Zone scales are available that can be pasted on the meter dial for rapid determination of exposure settings. These meters will generally perform well in the middle ranges, but many are not linear at the extremes. Typical problems that occur are overindica-

tions of very low brightnesses, which will result, for example, in underexposure in a library, and insufficient indications of high brightness, which will cause overexposure of a sunlit snow scene. The CdS cells employed are also variously affected by color, by temperature, and by their own memory. After making readings of areas of extreme brightness, it is necessary to rest the cell for a few minutes to avoid too high readings of an area of low brightness. For these reasons, a reliable meter of the selenium type such as the Weston V or VI is good back-up insurance.

Selenium meters are rugged and reliable, but because they read a rather wide area, close approach to the subject is required. They cost about one-fourth as much as the spot meters, and Zone scales are also available for them.

Meters in cameras are not recommended for precise use. They read the average of the entire scene or a loosely defined center-weighted area, readings that provide haphazard information at best. Because camera meters must work with camera controls and fit into or onto the camera, they must be designed within narrow physical limitations. An inconvenience is experienced when these meters require repair: The use of the camera is lost during that period.

Tripods

Sturdy, well-designed, well-made tripods are as rare as good meters and every bit as important. The Husky 3-D for cameras up to 2¼″ x 2¼″ and the Majestic for view cameras are recommended. Possibly the single factor causing the greatest loss in negative sharpness is slight camera movement. When tripods are used, print quality and composition are invariably improved. It is a fact that tripod-mounted cameras of moderate quality will produce sharper images than the finest cameras when hand-held. If a camera must be hand-held, it can be steadied considerably if the photographer leans a shoulder against a wall or tree or in some way firms up his stance.

Lenses

My most-used lenses are moderate wide-angle lenses such as a 35mm lens for the 35mm camera and a 121mm lens for the 4″ x 5″ camera. The second most-often-used lenses are the moderate telephoto—a 105mm lens for the 35mm camera and a 210mm lens for the 4″ x 5″ camera. In comparatively rare, special circumstances, a 28mm lens is used for the 35mm camera and a short 90mm lens is used for the 4″ x 5″ camera. I regard these as the shortest lenses that can be generally used without introducing distracting effects inconsistent with "straight" photography. A process-type 12″ lens for the 4″ x 5″ camera completes the group. It is used for close-ups requiring the finest resolution, for copying, and for distant views of small areas. I almost never use the standard focal lengths such as the 50mm for the 35mm camera. They always seem to be too short or too long for my purposes. All of the above are personal preferences: Henri Cartier-Bresson is said to use the standard 50mm lens almost exclusively and he does so with stunning effect.

Lenses should be carefully chosen for the anticipated work. Extremely short or long lenses, for example, have specific but limited uses. An African safari might require a 300mm lens for a 35mm camera for full frame photographs of distant wildlife, but after the trip that expensive lens is usually consigned to a drawer. It is possible to rent specialized equipment, but it must be thoroughly tested before the trip.

Enlargers

Enlarger design has lagged far behind camera design. Improvement over the last 20 years seems limited to added electrical gadgets. The need is for better design resulting in sturdier construction. An enlargement is a time exposure and the enlarger must be absolutely rigid if maximum resolution is to appear in the printed image. My enlarger is an Omega D-2 4″ x 5″ model that has been made rigid by wall mount-

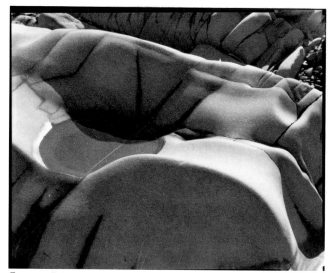

Contact Print

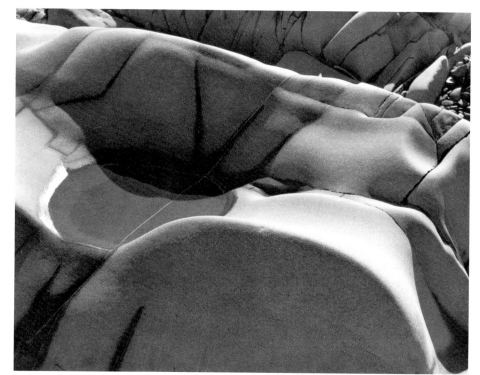

Cold Light Enlargement

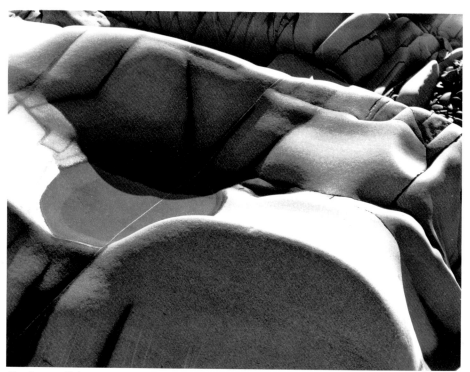

Condenser Enlargement

ing on a heavy steel bracket bolted to a 2″ x 6″ timber. The unsteady top of the inclined arm is immobilized by a large turnbuckle bolted to the wall. Beseler enlargers are well braced and do not require such modification if they are supported on sturdy bases. During printing exposures the photographer should stand still and keep hands off the enlarger support table to minimize vibration.

Lens lengths generally recommended for enlarging the various formats are too short for best results. A sharper, more evenly illuminated image, especially at the edges, will be obtained from a 35mm negative if an 80mm lens is used rather than the usual 50mm lens. A 150mm lens works well for 2¼″ x 2¼″ as well as 4″ x 5″ negatives.

Much can be learned about an enlarger's performance if a negative is exposed to a Zone IV or V density and subsequently enlarged. The exposure should be of a smooth card of any color or tone. This negative should be carefully focused with the aid of a grain magnifier and then printed so that a Zone IV, V, or VI print value results. The gray print will show the evenness of light distribution, sharpness of the grain at the edges compared to the center, and cleanliness of the lens and condensers. The full negative should be printed on the largest paper in normal use. Ideally, the result is an absolutely even, flawless gray print.

Enlarger Characteristics

The three prints opposite demonstrate a dramatic difference in print quality. All three are unmanipulated straight prints. All three prints are from the same negative, all were printed on the same paper, Ilfabrome No. 2, and all were developed exactly two minutes in Dektol, 1:2 dilution. Although the enlarging exposures in each case were the minimum for maximum black through the film edge, the results are quite different.

The first print is a contact print. Contact prints accurately reproduce the diffuse densities of a negative throughout its range. The center print is an enlargement made with an Omega D-2 Enlarger fitted with a cold light head. The only difference between this print and the contact print is the difference in size. The last print was made with the condenser head, which was the original equipment supplied with the enlarger. The abrupt breaks in tone and the flat, chalky, high values are typical of prints enlarged with these light sources.

In the nineteenth century André Callier discovered that beamed light (as from a condenser system) does not pass through the negative in proportion to the negative densities. The beamed rays are more scattered by the denser negative areas than by the thinner areas. The result, called the Callier Effect, is described in the clear, colorful language of Ansel Adams as "soot and chalk."

The greater the enlargement ratio, the more noticeable the Callier Effect. A 4″ x 5″ negative is enlarged only two times to make an 8″ x 10″ print while a 35mm negative is enlarged more than eight times to make an 8″ x 10″ print. It is surprising, therefore, that many workers in 35mm continue to use condenser enlargers. My experience has shown that small negatives need every bit of help they can get and that the benefits of cold light are even more obvious in prints from small negatives.

Darkrooms

My darkroom was designed with the help of Ansel Adams. Though it measures only 8′ x 10′, it is a pleasure to work in and visiting photographers who have used it agree that everything they need is available and conveniently placed. Prints to 16″ x 20″ can be made in the 2½′ x 9′ sink. All functions that can be performed outside the darkroom are relegated to a small workroom. Drying screens, mounting equipment and supplies, cameras, tripods, and wrapping materials are stored there.

Darkrooms, no matter how modest the space or sparse the equipment, can usually profit from reevaluation and reor-

ganization. Unused gadgets, jugs, chemicals, and out-of-date papers attract dust and cause clutter. If an item has not been used in six months, it should be discarded. The darkroom should be stripped of nonessentials, convenient storage arranged, wiring made neat and safe. A coat of paint, a reassessment of necessities and a reorganization of storage often convert a cardboard jungle into a pleasant place to work.

Cleanliness and order not only provide pleasant surroundings, but more important, they set a stage consistent with careful, precise work. If I had to work in some of the dirty, ill-lit, cluttered dungeons I've seen, I would send my film to the drugstore!

FILING SYSTEM

Filing negatives and proof sheets is a drudgery that becomes more oppressive the longer it is avoided. Some consistent system is required. I store consecutively-numbered commercial negatives with their proofs alphabetically under the account name. Personal work is filed by the year. My first 4″ x 5″ negative of 1974 is labeled 45-74-1 on the negative jacket and on the back of the proof sheet. Proof sheets are three-hole punched and filed in order in a ring binder. Negatives are filed in order in metal drawer files. 35mm negatives are filed separately from 4″ x 5″s, but an entire roll gets a number. The first roll is 35-74-1 and a specific negative can then be identified by its frame number. Since all proofs of negatives made on the same film receive the same exposure (see "Proper Proof" in *The Zone VI Workshop*), an easy system is to proof negatives as soon as they are dry and then file them. The exposed proofs can be put in a lighttight drawer or empty paper box until the next time the darkroom is set up for printing, then developed all together. The number is written on the back of the proof with an indelible felt-tipped pen. A separate ring binder is kept for each format and labeled with the current year.

FILMS, PAPERS, AND DEVELOPERS

Not long ago a new wonder film and developer arrived in the camera stores. The film was reputed to be sharper, have less grain, and encompass a range of tones superior to any film presently available. Pursuing my endless search for better materials, I purchased some of this film and its companion developer.

Before films can be compared (testing a product in isolation is a waste of time), equal situations must be set up. First, the film speed must be established relative to the equipment. The film speed setting is correct when a Zone I placement of an evenly lit surface provides a .10 density above film base plus fog. This film was rated ASA 80 by the manufacturer, but my test showed that my meter had to be set at ASA 8 to achieve proper density.

A further test to determine development time is necessary before valid comparisons can be made. The negative development time that would provide a printable Zone VIII density for the film was one-half the time suggested by the manufacturer. A reduction in development of that magnitude would be sufficient to reduce the Zone I density to the extent that the film would have to be exposed at about ASA 4—not ASA 8. I next made some photographs with the remaining film properly rated at ASA 4 and developed according to tested time. The results showed accuracy of exposure and development when the negatives were subjected to the "proper proof." The prints were terrible. A muddy range of tones with poor separation in the low values changed to harsh breaks of tone with poor gradation in the high values. The film was indeed sharp and very fine grained, but so is Kodak High Contrast Copy Film. Neither have a useable range or scale for general work.

Throughout this book the impression may have been given that I use Tri-X film and HC-110 developer to the point where other materials are of no interest. In fact, I am constantly searching for a film and developer combination that

would give me the speed and beautiful tonal range of Tri-X but with greater sharpness and smoother rendition of single-toned areas such as cloudless skies. So far, Tri-X has outperformed in important particulars those films, domestic and foreign, that I have tested.

Papers are generally poorer than they were in the past. Millions of prints are made on papers that cannot reproduce either rich black or pure white. The first test of a paper should be for these extremes. The papers to be compared are placed on the easel with a card covering half of each sheet. The other half is subjected to a gross overexposure. After the papers are developed, fixed, washed, and dried they can be compared. Are the blacks veiled or can you see right into them? Are the blacks black or dark gray? Are the whites clean and pure or a dingy yellow? Compare the surfaces. Are they smooth and rich or cold and hard as stainless steel? How about print color? A greenish chemical tone is particularly unattractive and a chocolate brown can be distracting. If a paper looks good except for color, it is worth some experimentation. A developer or toning formula may be found that will solve the color problem. If a paper can't pass the black and white test there is little reason to experiment further, but if it shows possibilities, prints should be made using different developers, dilutions, and developing times to find out how it behaves.

I like Ilfabrome No. 2 for certain subjects that will benefit from its warm tone. It gives an impression of depth and dimension to the subject, and creates an atmosphere of space, when developed four minutes or more in Dektol 1:2. This dimensional quality is not nearly as apparent when development is for the usual two minutes.

Varigam is colder in tone and has a different emotional quality. This paper has clarity and separation characteristics that work well with architecture, strong light and shadow effects, and portraits in open shade. This paper is brilliant. It has the advantage of being variable contrast, so a No. 1 grade print will match a No. 4 grade print in color and surface.

Many graded papers will show different range and color characteristics for the different grades. Kodabromide No. 2 will not show a clean black, nor will it respond well to toning, but the No. 3 and No. 4 will tone and have black capability. These papers are flatter, less brilliant than Varigam, but work well with some negatives.

All of the foregoing is subjective and each photographer should conduct his own tests to find the materials consistent with his expressive requirements. Try everything—follow no one's advice, but conduct controlled comparison tests. A product does what it does—not what someone says it does. The only criterion for choosing materials is their ability to deliver the qualities that you require in your prints.